IMAGES
of America

INDUSTRIAL BANK

IMAGES
of America

INDUSTRIAL BANK

B. Doyle Mitchell Jr. and
Patricia A. Mitchell with Lisa Frazier Page
Foreword by Edward Ellington Jr.
and April Ellington

ARCADIA
PUBLISHING

Copyright © 2012 by B. Doyle Mitchell Jr. and Patricia A. Mitchell with Lisa Frazier Page
ISBN 978-0-7385-9289-3

Published by Arcadia Publishing
Charleston, South Carolina

Printed in the United States of America

Library of Congress Control Number: 2012934601

For all general information, please contact Arcadia Publishing:
Telephone 843-853-2070
Fax 843-853-0044
E-mail sales@arcadiapublishing.com
For customer service and orders:
Toll-Free 1-888-313-2665

Visit us on the Internet at www.arcadiapublishing.com

This book is dedicated to all the present and past employees, board members, stockholders, and customers for their unwavering loyalty, steadfast dedication, and tireless efforts. May their commitment to a deserving community remind us of the power of unity.

CONTENTS

FOREWORD

A precious historical legacy with great vision, fortitude, and precedent setting.

An American success story!

THE LEGACY, THE PASSING OF THE BATON, THREE GENERATIONS STRONG

Pres. Franklin D. Roosevelt declared a bank holiday in 1933, closing all banks in the nation until they proved they were financially stable. Shortly thereafter, in 1934, Jesse Homer Mitchell established Industrial Bank of Washington during the Great Depression. It was the first black bank to open its doors in Washington, DC, on the famed U Street, known as "Black Broadway."

During an era when people of color were living in an environment full of racism and Jim Crow Laws, our people were forced to be innovative, independent, and entrepreneurial in disciplines such as music, banking, you name it. Jesse Homer Mitchell forged ahead. His vision and innovative fortitude laid the foundation for the path the Mitchell family would follow.

Our grandparents, Daisy and James E. Ellington, and our father, Edward Kennedy "Duke" Ellington, were neighbors and friends to the Mitchells and were customers of Industrial Bank from its inception. They survived the constant hurdles and prejudices with leaps and bounds and made it through ever-changing and difficult times with "flying colors."

In 1954, the baton was passed to the next generation: B. Doyle Mitchell Sr., a native son of Washington, DC, became president and chief executive officer of the bank. With the love and support of his wife, Cynthia T. Mitchell, along with her dedication to family, B. Doyle Sr. made it through with perseverance, determination, and integrity. The rich legacy continues with the current generation that now carries the baton—B. Doyle Mitchell Jr. and Patricia A. Mitchell.

Patricia and B. Doyle Jr. began working at the bank at 14 and 16 years old, respectively. After graduating from college, they both returned to the bank. Patricia now serves as executive vice president and is a member of the board of directors. B. Doyle Jr. now serves as president and CEO and is a member of the board of directors.

With nurturing and strength instilled in both Patricia and Doyle Jr. by their loving and dedicated mother, Cynthia, they have followed the path and are living the legacy of the Mitchell family's Industrial Bank with dignity and honor.

When we were in the selection process of choosing a bank to distribute the Washington, DC, Duke Ellington Commemorative Quarter in 2009, our beautiful mother concurred it was fitting for us to select Industrial Bank, as the Mitchells and Ellingtons share such a long history and enduring connection.

That being said, it is our absolute honor to have composed the foreword for the first literary work of this historical African American family, landmark institution, and our very beautiful family friends. Tracing the lineage of the Mitchell family in this book will serve as an inspiration and education to all who read it. May the legacy of the Mitchell family's Industrial Bank continue for many generations to come.

—April Ellington and Edward Ellington Jr., The Savoy Ellingtons

ACKNOWLEDGMENTS

For many years, my brother B. Doyle Mitchell Jr. said, "We have to get these people on tape." He was referring to those people who have the most significant historical knowledge of the bank and its past. They were passing away, taking with them stories that were fueled with passion for the bank. In this book, I invite readers to enter into an intimate conversation with the past, offering insightful commentary on the images. Everywhere in these images is a richness of detail that captures noteworthy historical events.

I would like to acknowledge the hundreds, if not thousands, of employees who worked tirelessly over the past seven decades and the 470 initial shareholders who invested hard-earned money during an era when $10 per share was a significant amount of money. The concept of starting a bank to provide loans to black people when majority banks refused to do so became a legacy no one could have imagined. Industrial Bank is still thriving 78 years later.

For me, compiling this book has been a three-year learning experience aided by many people. A special thanks to Sharon Zimmerman, who recorded and transcribed critical interviews of those who possessed significant historical information. Thanks also to Patricia Willard, who shared her expertise as a writer and guided me in the process of compiling a literary work. I also must thank Massie Fleming, my cousin Cordell Hayes, and Clinton Chapman, chairman of the bank's board, whom I called upon many times to assist me with identifying photographs and certain historical facts. Many thanks and much gratitude to our collaborative author, Lisa Frazier Page, for her patience and guidance as a talented writer.

The contributions everyone made to this book are significant beyond just providing facts and stories from the past. They, too, are keepers of the legacy of Industrial Bank. Unless otherwise noted, images are courtesy of Industrial Bank archives. Images credited SI are courtesy of the Scurlock Studio Records, Archives Center, National Museum of American History, Behring Center, Smithsonian Institution.

—Patricia A. Mitchell
Industrial Bank

INTRODUCTION

The earliest known banks to serve black customers date back to the Civil War, when Union generals set up military banks in some states to help black soldiers save their government pay. As the war was ending, John W. Alvord, a Congregational minister, summoned a group of fellow antislavery sympathizers and philanthropists and proposed establishing a nonprofit national bank aimed to teach black war veterans and newly emancipated slaves how to keep and grow their small earnings, according to a book by scholar Carl R. Osthaus. Alvord's idea evolved into the Freedmen's Savings and Trust Company, better known as Freedmen's Savings Bank, authorized by a federal law in March 1865, shortly after Congress approved the constitutional amendment that completed the abolition of slavery.

With vigorous support from former slaves, the bank expanded quickly, eventually opening 37 offices in 17 states. It provided valuable training and job opportunities for black workers—a source of pride that abolitionist and statesman Frederick Douglass later wrote about in his autobiography:

> In passing it on the street I often peeped into its spacious windows, and looked down the row of its gentlemanly and elegantly dressed colored clerks, with their pens behind their ears . . . and felt my eyes very enriched. It was a sight I had never expected to see. I was amazed with the facility with which they counted the money; they threw off the thousands with the dexterity, if not accuracy, of old and experienced clerks. The whole thing was beautiful.

However, Freedmen's Savings Bank would not last. A costly relocation of its headquarters from New York to Washington, DC, in 1870, followed over the next three years by poor management, alleged fraud, and a crippling international economic crisis, left the bank on the verge of collapse, Osthaus wrote. Freedmen's officials named Douglass president in March 1874 to lead the bank out of the crisis and help solidify the community's confidence. Douglass, however, soon discovered the magnitude of the bank's problems and petitioned Congress to close it. In June 1874, Congress ordered Freedmen's Bank to shut down, causing widespread distrust and anger among black depositors who never recovered their full investments.

Nearly 15 years would pass before black Washington once again established its own bank. According to an account written by black economic development advocate Andrew Hilyer in his 1901 book, a white official's demeaning comments prompted a group of black men to take action. "About twelve years ago a statement was made on the floor of the U.S. Senate by a prominent senator that with all of their boasted progress, the colored race had not a single bank official to its credit," Hilyer wrote.

Eight black businessmen and community leaders, stung by the criticism, called a meeting at the home of a local professor. Several of them were officers of the three-year-old Industrial Building and Savings Company, a black-owned business that provided mortgage loans to help customers buy homes. A full-service bank seemed to be the next logical step. By the end of their meeting, the men had put up the money to set up their own bank. On October 17, 1888, their Capital Savings Bank opened in northwest Washington.

Capital Savings Bank became the first bank in the country established and operated by black men. Nine months earlier, a black fraternal group called the United Order of True Reformers had incorporated another bank, the Savings Bank of the Grand Fountain, in Richmond, Virginia,

but it did not open officially until the following year, according to the Virginia Historical Society. These banks were a remarkable accomplishment for a disenfranchised people just two decades out of slavery.

The new Capital Savings Bank was housed in the same structure as Industrial Building and Savings at 609 F Street NW. The two businesses also shared some of the same officers, including Leonard C. Bailey, one of the bank's founders and its first president. Bailey was a wealthy businessman who owned several barbershops and, as an inventor, held patents for several devices used by the US government, including a folding bed for soldiers, a machine for processing mail rapidly, and a medical device to treat hernias, Hilyer's book says.

Bailey intervened when Capital Savings Bank was threatened by the severe economic crisis of 1893, which toppled financial institutions throughout the country. "Mr. Bailey's personal credit at one of the stronger National Banks enabled him to command a large sum immediately, and thus to make secure an enterprise whose failure would have affected the commercial integrity of the whole race," Hilyer wrote in his book, which was a directory entitled *Colored Washington: Efforts for Social Betterment*.

Captial Savings Bank was part of a broader effort by Hilyer, the first black graduate of the University of Minnesota in 1882, and many of the city's black businessmen to spur economic development in their community. In the directories he compiled in 1892, 1894, 1895, and the most extensive one in 1901, Hilyer documented the growing number of black businesses opening throughout the city. The majority of them were concentrated in the section of northwest Washington between Fourth and Fifteenth Streets and Q Street and Florida Avenue, which became known as Shaw.

With Captial Savings Bank, these businesses had somewhere to turn for financial help. Still, many of the businesses failed. Few of the owners had the education and expertise to operate with maximum efficiency and many of their potential customers patronized competing white establishments.

"At first blush, it seems a startling proposition that colored people are not disposed to patronize each other in those classes of businesses in which the whites also seriously compete for their trade," Hilyer said. "Of course the colored men cannot have a fair chance in business as long as he is shunned on account of envy and jealousy or a lack of confidence by any large part of his own race, especially in communities where they are numerous."

By 1902, Captial Savings Bank was struggling. It closed that year, and the old problem was new again: there was no black bank in the nation's capital. Black customers could make deposits at white banks but were rarely, if ever, granted loans.

A local black newspaper joined the voices calling for a black bank. An editorial in the *Herald,* a monthly newspaper published by the Washington chapter of the National Negro Business League, said the city needed "at least one banking institution that would safely house and properly invest . . . our people's earnings."

In 1913, John Whitelaw Lewis, a black businessman and developer, answered the call. Born in 1867 in Caroline County, Virginia, Lewis had taught himself how to read and write and then how to make money. In 1906, he formed the Laborers' Building and Loan Association to help working-class black men and women purchase homes. The next year, he founded the Laborer's and Mechanics Realty of Washington. In 1909, his Building and Loan Association constructed a new building at Eleventh and U Streets with enough space for many popular black businesses, including the Hiawatha 5¢ moving picture theater.

On May 1, 1913, Lewis opened the Industrial Savings Bank in the building on the corner of Eleventh and U Streets. A grateful community rallied to show its support. At the National Negro Business League Convention that year, Lewis told fellow entrepreneurs, "One of the most hopeful signs was when nineteen leading ministers of the city of Washington were among the first persons to be found at the door of that Negro bank . . . giving of their confidence and encouraging us to go on and then later telling their congregations to come on."

Within four years, the bank had 300 depositors and $35,000. It continued expanding and in 1921 counted 11,000 accounts and capital valued at $800,000. A.B. Caldwell, who edited the

Washington, DC, edition of the *History of the American Negro* in 1922, wrote, "Best of all, Mr. Lewis and his organizations have the confidence of the business world, and he himself stands high in the estimation of the leaders of both races."

The 1920s were a prosperous time. While New York's Harlem was enjoying an historic renaissance of talent, culture, and creativity, black Washington was experiencing its own period of enlightenment and growth. Lewis had provided the community its first luxury hotel, the Whitelaw, which opened in 1919 at the intersection of Thirteenth and T Streets. Constructed at a cost of about $160,000, the hotel was a modern, five-story building designed by black architect Isaiah T. Hatton. The hotel became a community gathering place, the site for elite balls and social events, and the overnight destination of many black celebrity guests, particularly those, such as Cab Calloway and Duke Ellington, who performed at U Street jazz clubs.

As America celebrated the excesses of the Roaring Twenties, black Washingtonians came to U Street to splurge. It was their "Black Broadway," said entertainer Pearl Bailey. It was their cultural center, their place in the world. It was where their money was as good as anybody else's, where they did not have to enter through the side or the back or up rickety stairs. It was where they could dress in their Sunday finery, exuding pride and sophistication.

But trouble was lurking. On October 29, 1929, a day that will forever be known as Black Friday, stock market prices tumbled to historic lows, and the resulting panic set off a ripple effect that would devastate the banking industry. Industries shut down, causing massive unemployment. Banks throughout the country were suddenly unable to collect on loans, especially those made to stock market investors whose holdings were suddenly worthless. Even worse, many of the banks had invested depositors' money in stocks that were now of little or no value. Frantic customers nationwide rushed to withdraw their savings. The banks, unable to fulfill their obligations, began collapsing by the thousands.

By 1932, company stocks had lost 80 percent of their value, and nearly a quarter of the country's workforce was unemployed. More than 13 million Americans had lost their jobs since 1929, and 10,000 banks—40 percent of those operating before Black Friday—had collapsed. Prudential Bank, a newer black bank, consolidated with Industrial Savings in September 1932, and the two hung on a little longer.

When Pres. Franklin D. Roosevelt arrived in Washington to take office in March 1933, the country had sunk into the Great Depression. President Roosevelt used his inaugural address to try to calm a petrified nation with a promise of straight talk, quick action, and ultimate recovery. Two days later, he signed an order declaring a four-day bank holiday, closing all remaining banks in the country to assess their financial soundness.

At the end of the four-day holiday, black Washingtonians were devastated to discover that their beloved Industrial Savings, which by then had accumulated assets totaling $909,000, would not be allowed to reopen. The bank's historical significance loomed large in the minds of black entrepreneurs who remembered the pride that having a black-owned bank had brought their community. It was time for them to act.

Among those leading the charge to open a new bank was Jesse Homer Mitchell, a Howard University–educated lawyer and realtor who also had been a vice president at Industrial Savings. Under Mitchell's shrewd leadership, a tenacious new institution would emerge: Industrial Bank of Washington. Mitchell would steer Industrial onto a successful path, and three generations later, it is still going strong. Today, Industrial is the Washington region's oldest and largest black-owned, black-operated financial institution.

One

RISING FROM
THE DEPRESSION

The nation was mired in the Great Depression in 1933 when Jesse Mitchell and his friends and business associates came together to do what only a few black entrepreneurs before them had done: establish a new bank to serve their community. Their ambitious plan required an act of Congress, but by the end of the year, the federal government had approved the group's plan to sell $50,000 in stock to finance the bank.

Despite the widespread devastation from previous bank closures, black investors from every corner of the city—churches, social clubs, businesses, and private individuals—stepped up to buy stock. With shares selling at $10 each, some investors bought a single share; for many, it was their first time ever buying stock. It was an incredible show of trust.

By April 1, 1934, more than 95 percent of the stock had been sold. The new bank—to be called Industrial Bank of Washington—received its certificate of incorporation from the US Treasury Department on August 13, 1934. Jesse Mitchell, a Texas-born renaissance man, was listed as president and investor Isaac Mason was vice president. On opening day, August 20, 1934, a total of 474 stock certificates had been issued—an impressive showing from a community still hurting from the economic fallout of the previous years. Investors had bought $65,000 in stock, exceeding the goal by $15,000. The first members of the board of directors were Jesse Mitchell, Walter S. Carter, Talley R. Holmes, Isaac S. Mason, Walter L. Carter, Jesse W. Lewis, W.H.C. Brown, Benjamin F. Arrington, William B. Harris, and B. Doyle Mitchell, Jesse Mitchell's son.

When Industrial Bank of Washington opened its doors on August 20, 1934, in the same building as its predecessor at Eleventh and U Streets, customers lined the street. Some were there to recover what they could from their savings in the old Industrial, since 35¢ on the dollar was made available from previous deposits. The next day, a headline in the *Washington Post* trumpeted the good news: "Bank Reopens; Receipts Top Withdrawals."

Industrial is believed to be the only black bank in the nation that opened during the Great Depression.

On October 30, 1933, Lewis A. Johnson, the owner of a small construction company, wrote to President Roosevelt to express the black community's concerns about the closure of Industrial Savings. Johnson, a Virginia native who had moved to Washington, DC, in 1925, said it would be a "calamity" if Industrial Savings remained closed. The White House staff promised a quick response and many believe the letter helped lay the groundwork for the new bank.

Many men and women had lost their savings when Industrial Savings closed, and they were skeptical about trusting again. Years later, Jesse Mitchell's son Benson Doyle Mitchell reflected on the times, saying, "In spite of the fact that the community knew that my father was a trustworthy person and a person of good business judgment, it was very difficult to sell the stock during this period." Ultimately, the community rallied around Jesse Mitchell's vision and bought stock (below).

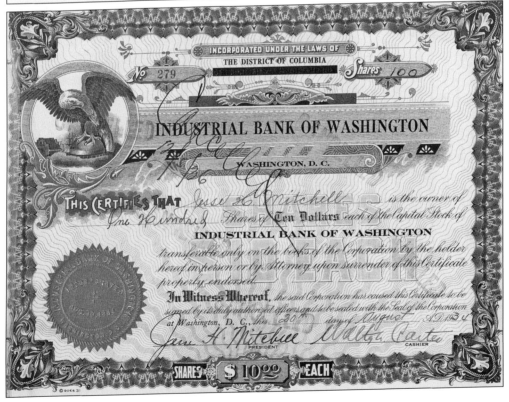

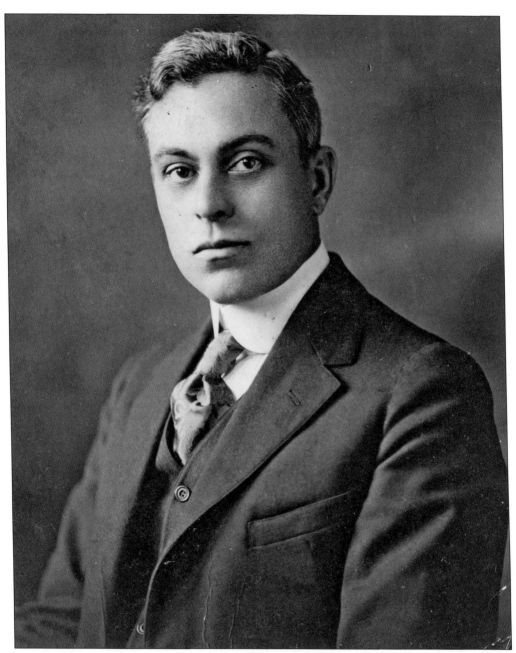

For Jesse Homer Mitchell, sitting at the head of the only black bank in the nation's capital was another new challenge in his life. He was born on December 2, 1881, in Navasota, Texas, about 70 miles northwest of Houston. According to his birth certificate, his mother was Rachel White and his father was unknown. Brenda Pace, Mitchell's granddaughter, said his mother was black and his father was white. After high school, Mitchell moved to Houston and worked briefly as a clerk at the financial firm R.G. Dun (later Dun and Bradstreet). He saved his money and enrolled at Prairie View State Normal and Industrial College. He graduated with honors and a bachelor's degree in education in 1904. Jesse worked for three years as a teacher and then moved to Washington, DC, to serve as a clerk in the US Navy department.

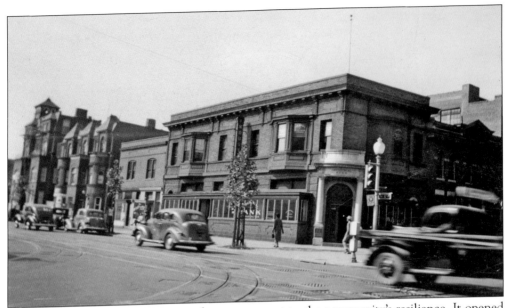

Industrial Bank of Washington stood as a testament to the community's resilience. It opened with six employees, including the Mitchells. The bank's first customer was Lewis A. Johnson, the contractor who had written to President Roosevelt. Many white banks sent flowers as a show of respect to Mitchell and a fellow bank rising from the rubble of the Great Depression. Dr. Emerson A. Williams, who moved to Washington, DC, in the early 1930s, recalled the community of black businesses on U Street back then, saying, "Just down the street from the bank, we had one doctor, and we had an architect. Across the street we had Reeves Corner . . . that used to sell clothing . . . And then you had a jewelry store there. We had a couple of dentists. My father's parsonage was in that block . . . We had everything . . . We knew we were going to succeed, and failure just wasn't in it."

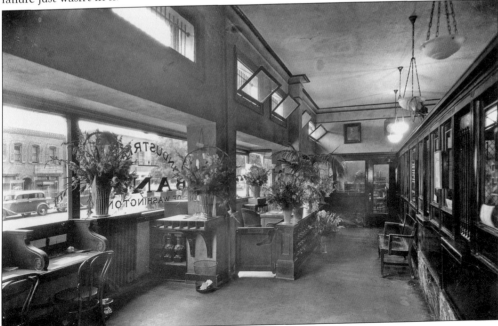

At Industrial Bank of Washington, there was no mistaking who was the boss. Mitchell sat near the front entrance, and if customers needed a loan, they were directed to him. When they applied for a mortgage loan, Mitchell and his good friend, realtor and fellow Industrial board member Talley R. Holmes Sr., would first assess the property. Holmes's son Talley R. Holmes Jr. recalled, "They would go out every afternoon and visit houses that people wanted mortgages on to see if they were worthwhile. They'd go out around two o'clock to three o'clock, after the bank had closed and do their appraising, and then afterwards, they'd all go to a real estate broker, Henry Penn, who had an office at Ninth and R or S Street, and sit around and relax, drink a little liquor, talk and make deals . . . At that time, there was no television, and everybody hung out together after work just to talk and do their deals."

Mitchell's strongest supporter was his wife, Beatrice, whom he married in 1912. A fellow Texan, she had moved to Washington, DC, as a child. She graduated from Howard University and attended its pharmacy school but could not find a job. She became a science teacher in 1928 and spent most of her career at Benjamin Banneker Junior High. The couple's first child, Benson Doyle Mitchell, known by most as Doyle, was born in 1913. Five years later, daughter Rosina was born.

Mitchell (seated center) poses with his son Doyle (fourth from right); his wife, Beatrice (third from right); and other associates, including original board member and vice president Isaac Mason (seated far left), one of the bank's largest investors with 484 shares, and Talley R. Holmes (standing center), also an original board member.

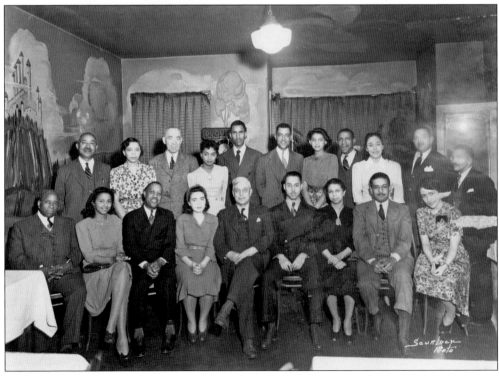

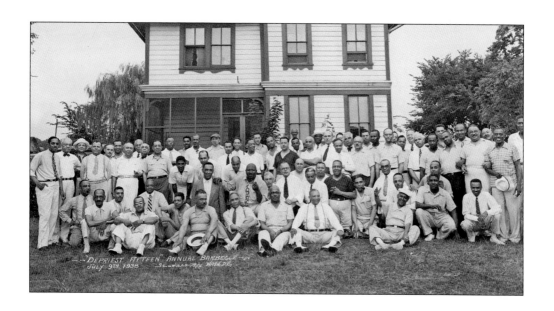

Jesse Mitchell surrounded himself with like-minded black men of the 1930s, many of whom were successful entrepreneurs and professionals. One such group was the DePriest Fifteen. Members are shown above at their annual barbeque in 1938. Spouses and other guests sometimes joined them for their events, as depicted below in 1946. Long before networking became the catchphrase of a new generation of young black professionals, Mitchell and his friends recognized the benefits of sharing information and the lessons they had learned along the way. If their gatherings extended well into the night, so be it. At work or play, Mitchell was not much of a clock-watcher. His beloved black Chrysler—his top choice in automobiles—was parked outside the bank on many late nights. (Courtesy of SI.)

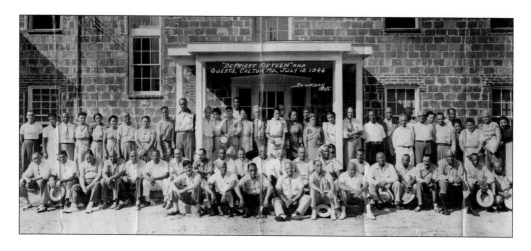

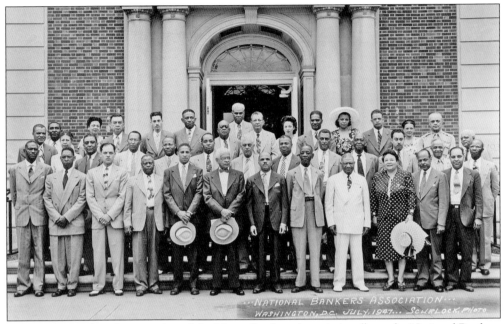

Industrial was a founding member of the Negro Bankers Association (later the National Bankers Association). The group began in 1927 in Durham with representatives from 14 black banks. Members elected Major R.R. Wright, then 72, of Philadelphia, as president, and he held the position for 15 years. Jesse Mitchell replaced him in 1942. The group, seen here in 1947 in front of Founder's Library at Howard University, included a few pioneering women.

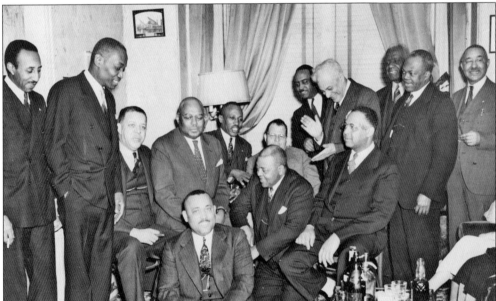

Mitchell's friends and business associates were like a brotherhood. Some evenings, the men gathered in the living room of the Mitchell home to play whist and talk business. The Old Forester bourbon began to flow, cigar smoke curled up and filled the room, and the conversation swirled from politics to business to community. The idea for the new Industrial Bank of Washington likely came out of such a night.

Mitchell enjoyed the nightlife, and his standing in the community gave him access to black celebrities. One of the highlights of his life was attending a birthday party in the late 1940s for boxer Joe Louis, who was then the world heavyweight champion. Louis cut his birthday cake that night with help from music giants Ethel Waters and Duke Ellington. Mitchell was also a fervent Republican; two highlights of his life included attending the GOP conventions in 1948 as an alternate delegate and in 1952 as a delegate. The latter convention launched Dwight D. Eisenhower into the presidency, but Mitchell was most enamored with another Republican president, Theodore Roosevelt, whose favorite proverb, "Speak softly and carry a big stick," seemed an apt description of Mitchell's own diplomatic style.

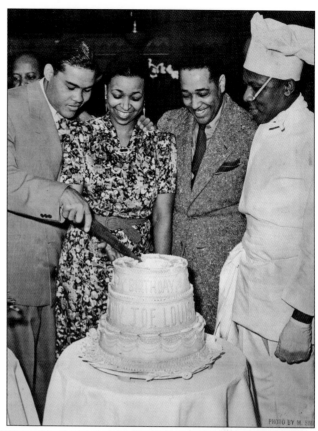

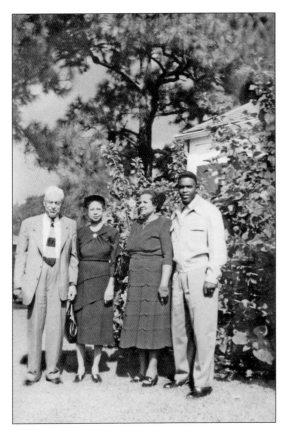

Baseball legend Jackie Robinson (far right), seen here with Jesse and Beatrice, was another celebrity friend of Mitchell's. One evening when Mitchell returned from a party out of town, he gave his grandson Cordell Hayes, then eight or nine years old, a baseball autographed by Robinson. Cordell could not resist throwing the baseball with the neighborhood kids, eventually destroying a valuable souvenir—a decision he regrets to this day. Hayes, his sister Brenda, and their parents, Rosina and Herman, all lived with the Mitchells in LeDroit Park.

Mitchell always wore a suit and tie and had a penchant for El Producto cigars. He also loved politics but never sought public office. As the bank grew, Mitchell's stature also increased. His grandson Cordell remembered, "There was some talk of him becoming a city commissioner, and I recall seeing a large billboard of him on Sherman Avenue holding a Lucky Strike in his hand. He didn't even smoke cigarettes."

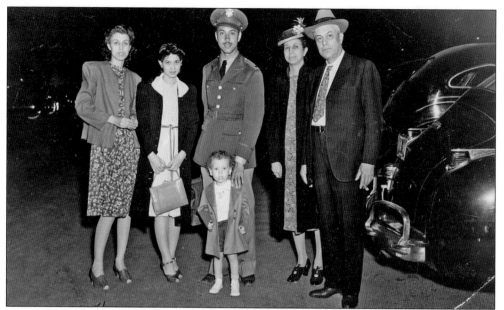

Mitchell's son Doyle served four years in the Army during World War II and then joined the Army Reserve, rising to the rank of colonel. Here, he stands in full uniform with, from left to right, his sister, Rosina; his first wife, Juanita; his nephew, Cordell; and his parents, Beatrice and Jesse. Jesse Mitchell's beloved black Chrysler is in the background. Every now and then, the busy grandfather took young Cordell for a ride. (Courtesy of SI.)

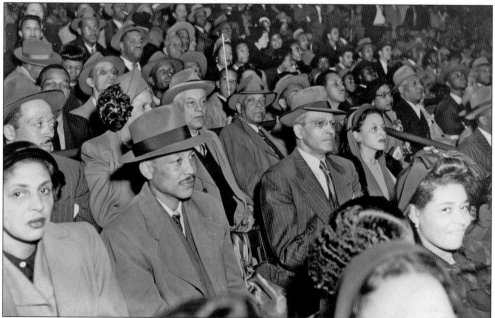

In 1949, Jesse Mitchell and George E.C. Hayes (with Doyle in the same row) joined a crowd at the old Griffith Stadium, which from 1911 to 1965 was at the corner of Georgia Avenue and W Street in northwest Washington. In the 1930s and 1940s, the stadium served as a part-time home for the local Negro League team, the Homestead Grays, and hosted the Capitol Classics, an annual black college football competition.

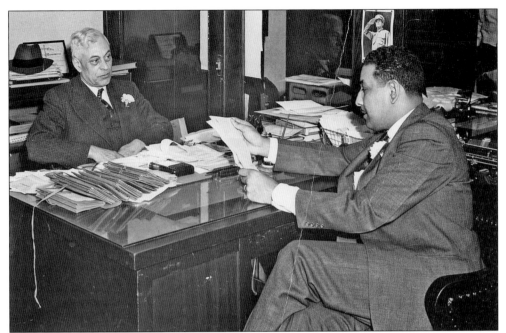

Those who knew Mitchell said he treated his employees and customers with courtesy and respect. He was a conservative and scrupulous banker who did not believe in wasting money. Doyle Mitchell shared an early memory of his father, saying, "Quite often when my father was employed in the Navy Department, he would walk home from work at Seventeenth and Pennsylvania Avenue Northwest to our home at Twelfth and S Streets to save a nickel."

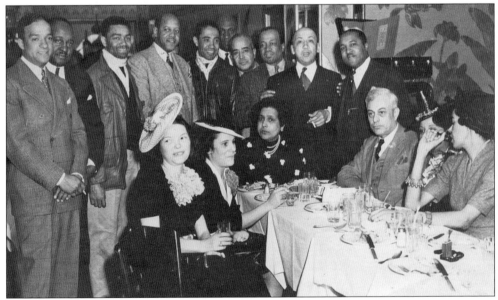

Mitchell always seemed to attract an elegant crowd. In 1952, his home state bestowed on him its Citizen's Award during the Texas State Fair. The same year, he was honored at the Willard Hotel. That night, he spoke about his role, saying, "The simple duty of a banker is to stand between and draw together the man who needs and the man who has the funds. I have done my duty and no more."

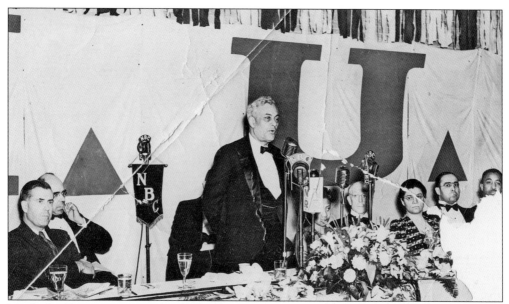

Mitchell addresses a group at his alma mater, Howard University, where he attended law school part-time, graduating in 1910. Seated to his right was renowned Howard president Mordecai Johnson, the Baptist minister who was named to the presidency in 1926 at age 36. Johnson would serve as the president of Howard for 34 years. (Courtesy of SI.)

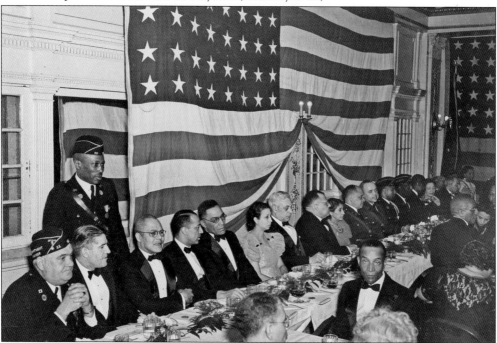

The nation's capital had a thriving black middle class in the 1940s and 1950s. Self-reliant black men and women made the most of segregated Washington, and they were proud that their community had its own bank. They often came together for black-tie affairs, like the one Jesse and Beatrice Mitchell were photographed at here. Jesse's friend, attorney J. Franklin Wilson, stood to the left of the flag in full military attire. (Courtesy of SI.)

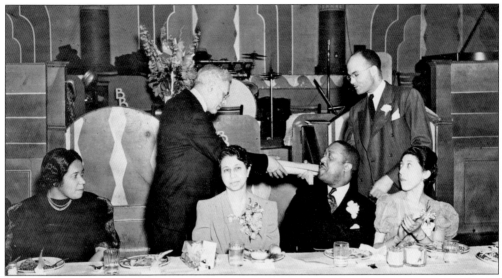

Attending community functions was a regular part of Mitchell's role as a community leader and banker. He belonged to numerous organizations and served in various leadership positions. The groups included the National Negro Business League, the Washington, DC, Chamber of Commerce, the Twelfth Street YMCA, and the District of Columbia's Prince Hall Masonry. He and Beatrice were also active at Lincoln Temple Congregational Church. In this photograph, he is part of a presentation. (Courtesy of SI.)

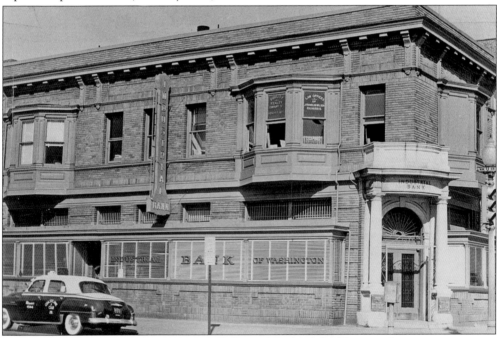

By 1953, a neon sign hung from the second floor of the bank building, marking its prominence on historic U Street. The law office of Mitchell's friend, attorney J. Franklin Wilson, is seen here above the bank. As the years passed, the elder Mitchell relinquished more and more control of the bank operations to his son Doyle and Doyle's friend Mervin O. Parker, who joined the bank in 1936 right out of Howard University.

Mitchell received numerous awards over the years for his service to his community and his country. His many commendations included a selective service medal awarded by congress and signed by President Truman. He also received a certificate of appreciation for his selective service work from President Roosevelt.

In the name of the

Congress of the United States

There is issued herewith

The Selective Service Medal

to

JESSE H. MITCHELL

In appreciation of your loyal and faithful adherence to duty given voluntarily and without compensation to the impartial administration of the Selective Service System, the Government of these United States expresses its gratitude in this public recognition of your patriotic services.

Attest: Lewis B. Hershey,
Director of Selective Service

Harry Truman
President of the United States

The President
of the United States of America

has awarded this

Certificate of Appreciation

to

Jesse H. Mitchell

in grateful recognition of uncompensated services patriotically rendered his country in the administration of the Selective Service System for the period of two years.

President,
Board of Commissioners, D.C.

Attest:

State Director.

Franklin D. Roosevelt

Lewis B. Hershey,
Director.

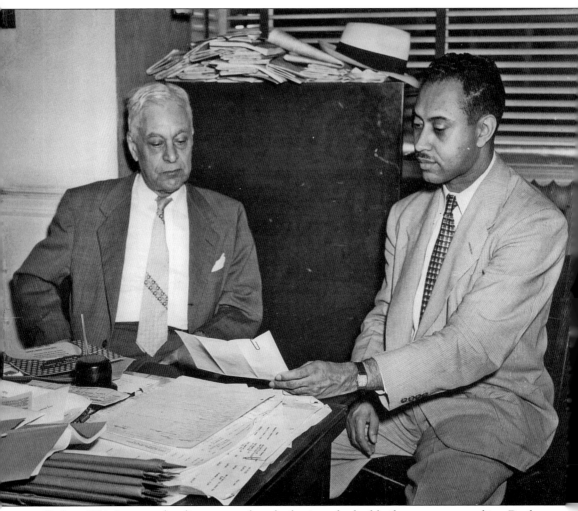

By late 1954, Jesse was battling cancer, but the business he had built was a source of joy. Doyle reflected on his father's last days, saying, "He loved the bank. While he was ill, he wanted to go to the bank and just sit for about an hour before returning home." In December 1954, Jesse relinquished the bank presidency to Doyle. Jesse died on March 5, 1955, ending an era.

Two

Dawning of the Son

When Benson Doyle Mitchell assumed the presidency of Industrial Bank of Washington in December 1954, it had become the largest black-owned bank in the country. With assets totaling nearly $7 million, Industrial remained the only black bank in the nation's capital.

At age 41, Doyle was aptly prepared to move into his destiny. He had grown up in Washington's black middle class, surrounded by success and high expectations. He attended Dunbar High School in its heyday and majored in mathematics at Howard University, his father's alma mater. Few events seemed more life-defining than the 1929 stock market crash, just weeks into his freshman year. As a result, he would forever be known for his frugality.

As a college student in the summer of 1930, Doyle went to work at the old Industrial Savings Bank. He continued working there during summers and weekends as the nation's economy spiraled downward. He developed a love for banking in those years and appeared to walk away from the experience with a fierce determination never to repeat the industry's failures. He became reluctant even to discuss the old bank and was careful to note that, despite the similarity of the names, the two banks were very separate entities.

After a year of graduate studies at the University of Pennsylvania's Wharton School of Business, Doyle joined his father full time at Industrial. He took great pride in the fact that, even as the heir apparent, he started in an entry-level bookkeeping position and worked his way up.

Quiet, unassuming, and extremely humble, Doyle and his second wife, Cynthia, whom he married in 1957, attended the obligatory receptions, dinners, and black-tie affairs. But the new bank president seemed most at home behind his desk at the office. He shared his father's taste in cars, and his employees regularly saw his Chrysler parked out front for long nights and on weekends. His careful and consistent leadership would guide the bank through nearly four decades of prosperity, challenge, and change.

Doyle was his parents' first child, born in 1913. His father wasted no time teaching him about money. Remembering his childhood years later, Doyle said, "When I was about 10 or 11 years old, my father was a trustee at Lincoln Temple Congregational Church and would bring the collection home on some occasions and would have me to help him count the money to verify the previous count. In this way, he gave me experience in handling cash. When I was about 12 years old, he required me to go alone to the bank, make out a deposit slip and deposit $2 from my penny bank."

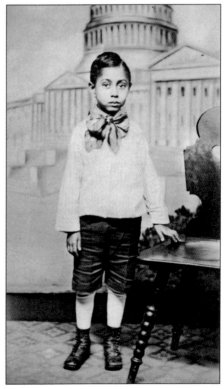

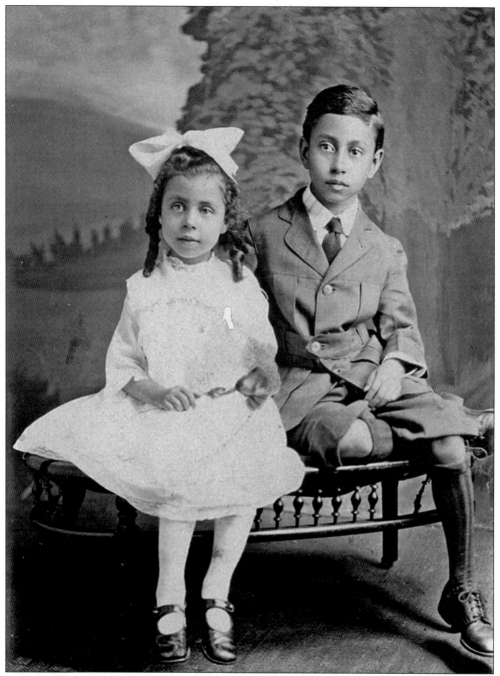

Both Doyle and his younger sister Rosina were raised to believe that black people should be self-sufficient, that they should open their own businesses and support other black entrepreneurs. Doyle was just about six years old when his father, an entrepreneur at heart, took a huge risk, walking away from the security of his federal government job to pursue full time his own business, the Columbia Realty & Investment Company. The elder Mitchell poured all of his energy and time into the success of his business, acquiring and selling properties within Washington's black population. By watching him, his children learned the value of hard work.

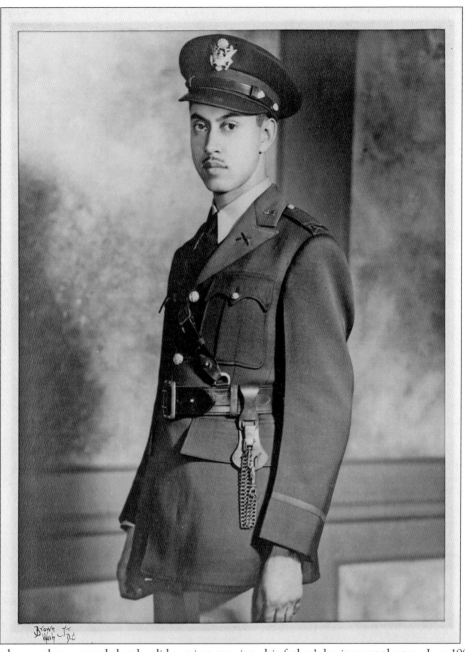

Doyle was always proud that he did not just step into his father's business at the top. In a 1992 interview that ran in *NBA Today*, he said, "Well, I think that working your way up is much better than starting out at the top and later trying to understand the way things operate at lower levels. If you start out at the bottom, you understand what a check is and what processes it goes through, particularly in the bookkeeping department. And you know you can be ruined if your bookkeeping department is not functioning properly." Doyle was working his way up at the bank during World War II when military duty called; he served four years in the Army and then joined the Army Reserve. He married his girlfriend, Juanita, and they had two daughters. However, the marriage did not last, and both daughters died young.

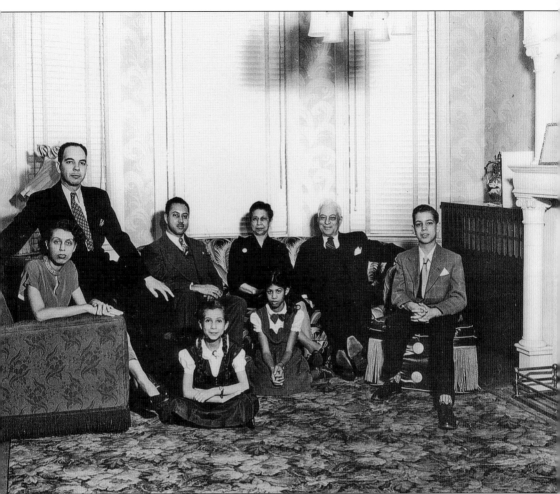

Family was important to Jesse and Beatrice. While business kept Jesse away much of the time, Beatrice kept things in order at their home on W Street NW in LeDroit Park. Beatrice was a strict disciplinarian, tolerating little nonsense, even from the grandchildren. For awhile, Rosina, her husband and children, and Doyle all lived with Jesse and Beatrice. To Cordell, Rosina's son, Doyle was a generous and compassionate man who was like a father to him. Seen here at their home are, from left to right, Rosina Mitchell Hayes; her husband, Herman Hayes; Doyle; Beatrice; Jesse; Cordell; and, seated on the floor, Brenda Hayes and Darlene Mitchell.

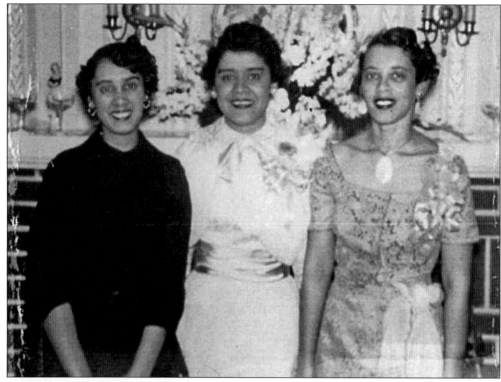

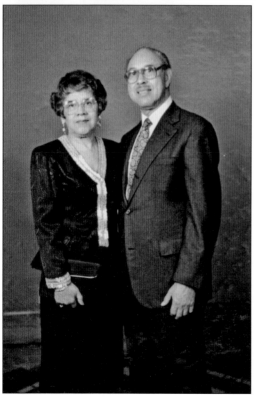

One of the happiest days of Doyle's life was December 6, 1957, when he married Cynthia Thompson, a fellow Howard University graduate and music teacher, in a simple ceremony at her mother's home. Cynthia (center) is seen above with her two sisters on her wedding day. In his new bride, Doyle found a devoted, take-charge woman who accepted the personal sacrifices required to grow a family business, especially the time commitment. Friends and family said they never heard her complain, though Doyle spent much of his time at work. The couple had two children, Patricia, born in 1960, and Benson Doyle Jr., born in 1962. They eventually moved to Crestwood, a newly integrated, upper-middle-class neighborhood that backed up to the breathtaking Rock Creek Park, but their lifestyle was far from lavish. Both Doyle and Cynthia watched every penny. Doyle Jr. said he hardly felt middle class when his mother made him wear "high water" pants that he had outgrown and slipped cardboard into the soles of his Chuck Taylors to extend their use after he had worn holes in them.

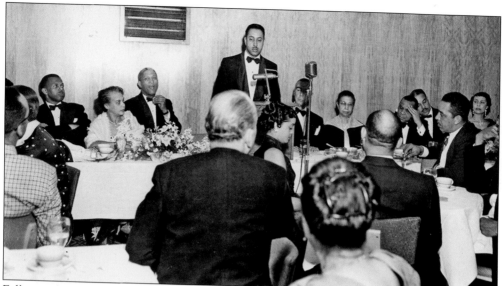

Following his father's trail, Doyle was also a community leader. He spoke at many black-tie events, and his proud mother, Beatrice (second from the right), often attended. But her husband's death had broken Beatrice's heart. On Memorial Day the year after he died, she laid flowers on his grave, returned home, and suffered a fatal massive heart attack. Her death stunned family members because she had rarely been sick.

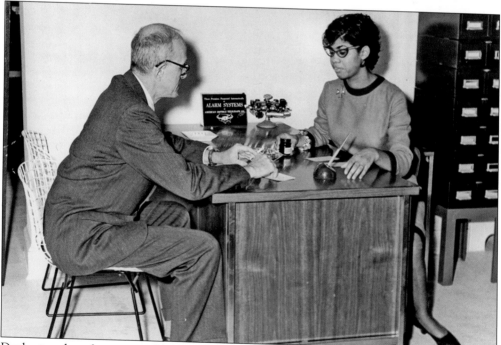

Doyle stayed as close as possible to his daughter from his previous marriage, Darlene Mitchell (later Darlene Tinner). Cynthia embraced Darlene, also, and Doyle's oldest child joined the family business, working in various clerical positions at the bank. But Darlene was 23 when she died tragically on April 2, 1966. She was the mother of a young daughter, Terri Tinner, who stayed close to the Mitchell side of her family.

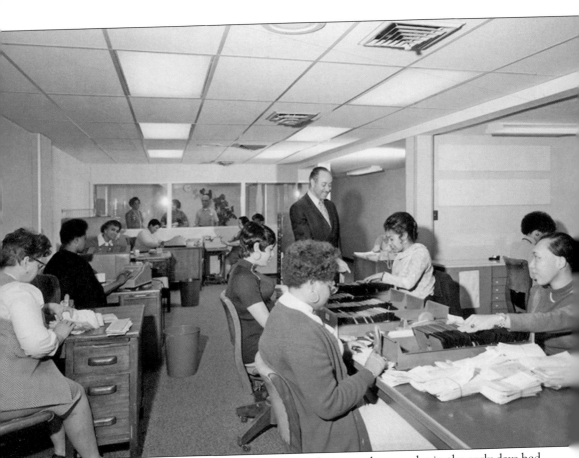

Industrial Bank provided a family-like environment for its employees, who in the early days had to do all of the bookkeeping by hand—from setting up customer accounts to updating them with deposits and withdrawals. Bookkeeping was a sort of proving ground, and employees who did well there often moved up. Before 1963, accounts were detailed on ledger cards and filed alphabetically. Industrial became one of the first banks in DC to convert to an automated check-posting system, inspiring others to follow. In the 1992 NBA Today interview, Doyle discussed the troublesome old system, saying, "We had a number of accounts which had the same name or very similar names, and some people who submitted deposit tickets failed to fill out their entire name. That caused us to get accounts mixed up. For example, we found out, while in the conversion process that we had two accounts with the same first and last name. The only difference was the middle initial. We had a hell of a time getting that straightened out."

Doyle was president of the National Bankers Association from 1959 to 1966, one of the group's longest presidential terms. The organization was a tremendous resource for Industrial, especially in the early days when there were few available training opportunities for black bank employees. Since its founding in 1927, the group has expanded to include minority- and female-owned banks. Its members now include banks owned by African Americans, Native Americans, American Indians, East Indians, Hispanic Americans, Asian Americans, and women. Above, Doyle attended a session during the 1964 joint conference of the NBA and the National Business League with Samuel Foggie (far right), who was once an officer at Industrial and went on to become president of another black bank. In the group photograph below, Doyle stood with other NBA members in the 1970s.

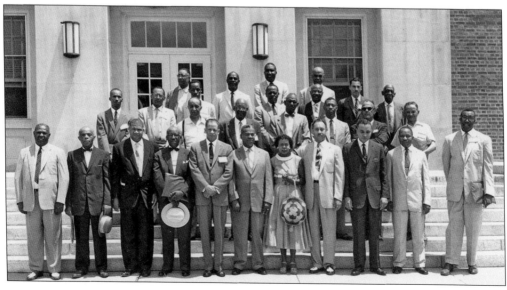

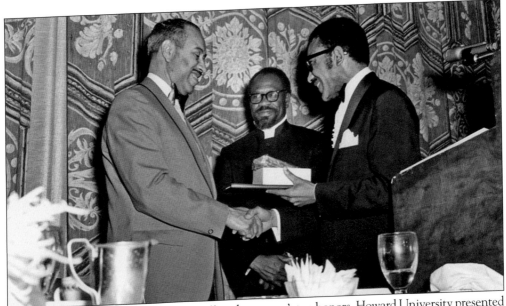

On March 2, 1972, Doyle received one of his alma mater's top honors. Howard University presented him its Alumni Award for Outstanding Service in Banking and Community Service during the annual Charter Day dinner. Doyle graduated from Howard in 1933 with a bachelor's degree in mathematics. Howard must have seemed like an oasis for the fortunate sons and daughters who could afford a college education during the economic chaos of the 1930s. Doyle was a student there when his father first got him a job at the old Industrial Savings in the summer of 1930. Whatever lessons Doyle learned as a young man watching an industry in crisis from the inside, he was determined to operate with character and integrity when it was his time to lead. His employees and customers say he did just that. At the Charter Day dinner, Howard University president Dr. James E. Cheeks, seen here shaking Doyle's hand, presented the award.

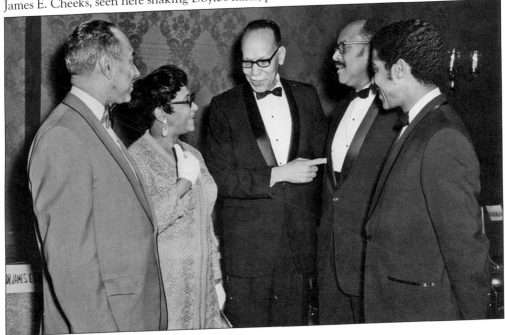

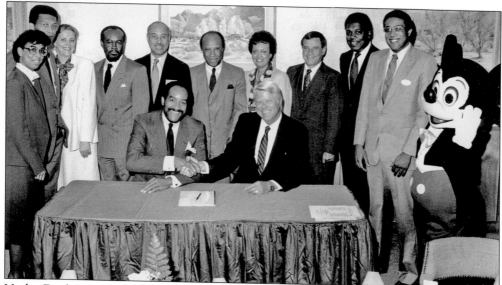

Under Doyle's steady leadership, Industrial grew significantly and continued to expand its customer base. Part of the bank's growth included partnering with other minority banks to provide "participation loans" to major corporations, such as Walt Disney, which had pledged a certain amount of its business to minority-owned financial institutions.

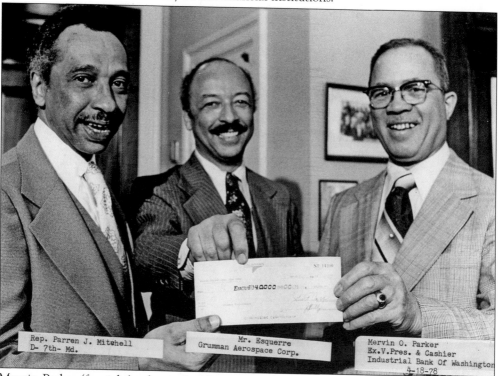

Rep. Parren J. Mitchell
D- 7th- Md.

Mr. Esquerre
Grumman Aerospace Corp.

Mervin O. Parker
Ex.V.Pres. & Cashier
Industrial Bank Of Washington
4-18-78

Mervin Parker (far right), who worked his way up from teller to executive vice president and cashier, is shown here in 1978 with former congressman Parren J. Mitchell (far left) and Mr. Esquerre of Grumman Aerospace Corp. (center). Doyle brought Parker, a high school and college friend, into the family business.

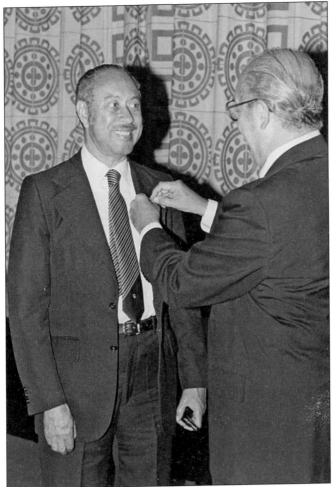

In 1981, Doyle became the first African American elected president of the DC Bankers Association, an organization that before the mid-1960s had refused to admit him and his bank as members. The presidency made Doyle the first African American to head a state-level banking association. His election to the group's top post had been set in motion the year before when Doyle was elected the group's first vice president, the person who traditionally was elected president at the end of the term. On the day Doyle took office, the group's outgoing president, Daniel J. Callahan III, declined to pin him. Instead, Doyle was pinned by a former president of the group, Leo Bernstein. At the ceremony, Doyle received a congratulatory kiss from his wife, Cynthia, who was incensed by the pinning incident, family members said. She was as protective of her husband as she was proud of him.

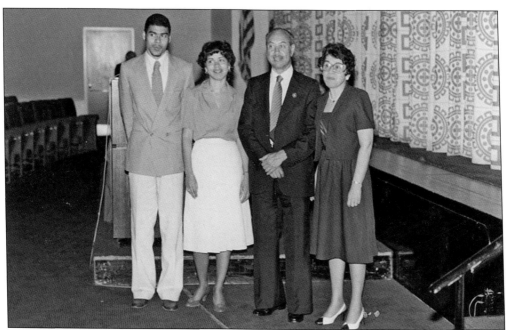

Doyle and Cynthia's two children, Doyle Jr. and Patricia—seen above with their parents before a formal event at the DC Bankers' Association conference—also celebrated their father's election to the group's presidency. Both had started at the bank as teenagers, answering the switchboard during summer breaks. Both said they learned humility by watching their father. Doyle Jr. recalled, "Sometimes I'd go with him on Saturday to the branches. Eleventh and U had really become the ghetto—guys drinking, selling drugs. But Daddy didn't turn his nose up at anybody. He'd wave. He knew the people." Their father never mentioned his status at the bank, regardless of where he went or who might have found it impressive.

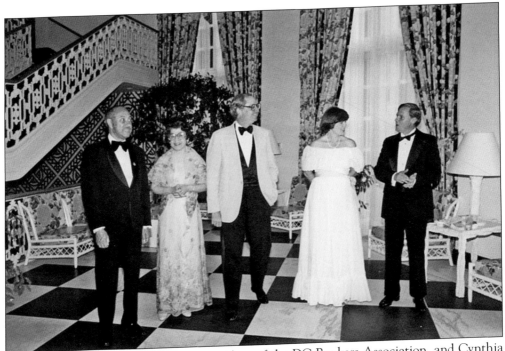

In the above image, Doyle, the new president of the DC Bankers Association, and Cynthia greeted guests waiting in a receiving line to congratulate him. Below, he socialized with fellow bankers during an outing. He earned the respect of his white peers with his fiscally conservative, consistent approach to banking. Colby King, a columnist for the *Washington Post*, a former Riggs National Bank vice president, and a member of the DePriest Fifteen, said the following about Doyle in a 1993 *Post* story: "Doyle never strayed from the fundamentals, for which I guess some people criticized him at the time, but in the end it is his bank that is still standing. He never went in to lending to developers and he didn't try to compete against Riggs or American Security . . . He was a banker, not an entrepreneur."

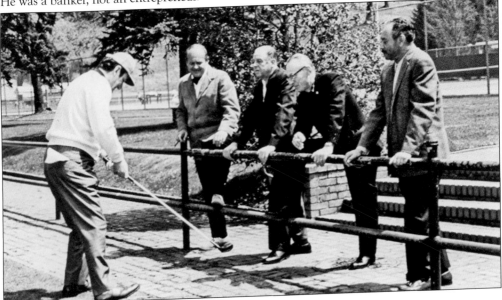

Three
BUILDING THE BANK

Soon after he went to work full time at Industrial, Doyle recruited his high school and college buddy, Mervin O. Parker, to join him. Parker had held just one previous job, as a short-order cook at Mrs. K's Tollhouse Tavern. But Doyle sensed that his friend's dedication and hard work would make up for his lack of experience. Parker began as a teller, but no job was too small, and he even filled in occasionally for the janitor and security guard. He was among the many early employees and board members who helped build Industrial Bank.

As Doyle rose to the head of the bank, so did Parker, who spent his entire 42-year career at Industrial Bank. In 1955, he hired Evelyn Robinson, who relocated to Washington, DC, just weeks after getting married. She had graduated from college and worked for 11 years at Mechanics and Farmers Bank in Raleigh, North Carolina. When her supervisor learned she was moving to Washington, DC, he suggested that she give Parker a call, but Parker called her first. Excited about her experience, a rarity for a job prospect in those days, he offered her a job over the telephone. She started as a savings teller and worked for 45 years at Industrial, eventually becoming the board's recording secretary and vice president.

Most of the bank's workers felt a strong sense of purpose and loyalty; some spent their entire careers there. Drapher A. Pagan Sr., for example, was hired in 1949 and over 44 years became senior vice president. He was playfully called "the sheriff" after he had pulled out his own gun during two separate robbery attempts, sending the shocked would-be robbers scrambling.

Of all the employees, though, no one climbed higher than Massie Fleming, who started as a bookkeeper in 1952 and over 46 years rose to chief executive officer. "Once I started working at the bank, it never occurred to me to look for another job," she said. "I think that was just the way it was with most of us here."

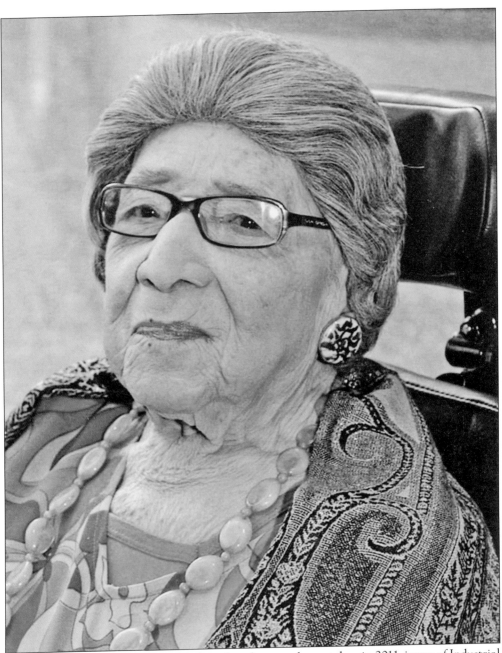

Alyce Dixon, who was 103 years old when this photograph was taken in 2011, is one of Industrial Bank's oldest and most loyal customers. She was 17 when she moved to Washington in 1924 and opened an account at the old Industrial Savings Bank, "the best Negro bank in the world," she said. She said she was the first black secretary at the Lincoln Theatre and also worked occasionally as a cashier there. From her weekly salary of $15, she gave her mother $5 to help out with her eight siblings and she deposited $3 into her savings account. When Industrial Savings closed, Dixon lost most of the $365 she had saved. By then, she was living in New York, but she still used the $65 she was able to recover from her previous account and opened an account with the new Industrial Bank of Washington.

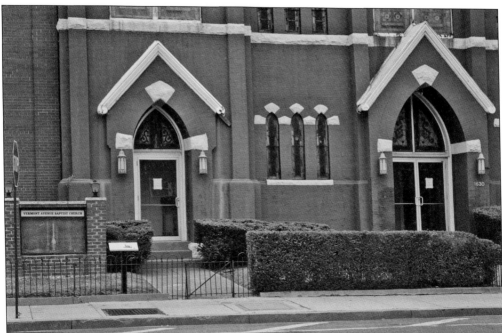

Vermont Avenue Baptist Church, seen here, was one of the bank's first shareholders. Black churches have been among Industrial Bank's most reliable customers. Federal regulators commonly misunderstood the large concentration of church loans held by Industrial. Such loans were considered risky because if a church defaulted, banks worried about the consequences of foreclosing on a house of worship. Massie Fleming, who often sat through Industrial's federal examination process, explained: "The examiners criticized us for having a high concentration of loans to black churches, and my response used to be that we believe firmly that God is not going out of business . . . That's one of the reasons why we were as successful as we were—because of the support of many of the black churches." The bank experienced its first loss on a church loan after more than 60 years in business.

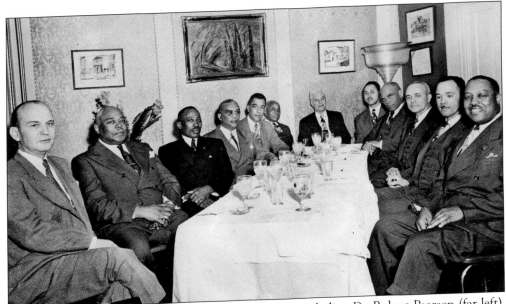

Jesse socialized with an accomplished group of friends, including Dr. Robert Pearson (far left), attorney J. Franklin Wilson (third from the left), real estate broker Talley R. Holmes (fifth from the left), Mervin Parker (second from the right), Col. Campbell Johnson (third from the right), and Dr. Henry Carmichael (fourth from the right). Holmes was an original board member and one of Jesse's closest friends and business associates. (Courtesy of SI.)

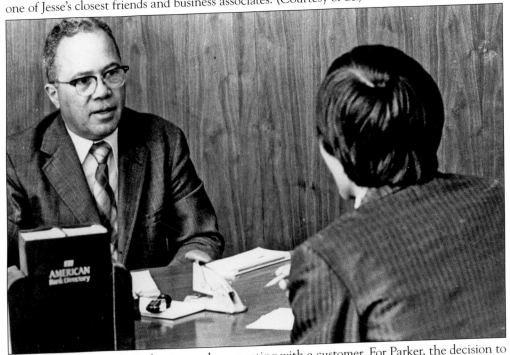

Bank executive Mervin Parker is seen here meeting with a customer. For Parker, the decision to work at Industrial right out of college was easy. He was close to the Mitchell family. Parker recalled: "I was just another son to the family really, and I'd go over to eat with them on weekends. Mrs. Mitchell was just like a mother to me, and Old Man was just like a father to me."

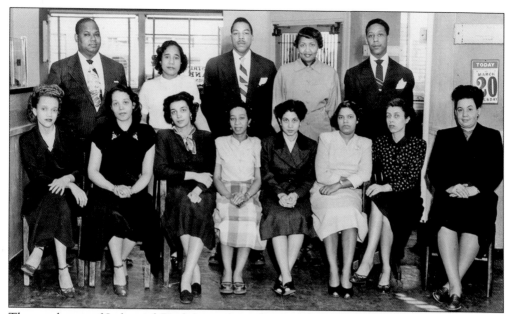

The employees of Industrial Bank have always been its strong foundation. They have worked hard, dedicating themselves to the bank's mission of serving the community. These workers in 1951 are, from left to right, (seated) Virginia Peters, Marion Brown, two unidentified women, Juanita Mitchell, Ernestine Mann, Rosina Mitchell Hayes, and an unidentified woman; (standing) Birchard Allen, Zenobia Carter, and three unidentified employees.

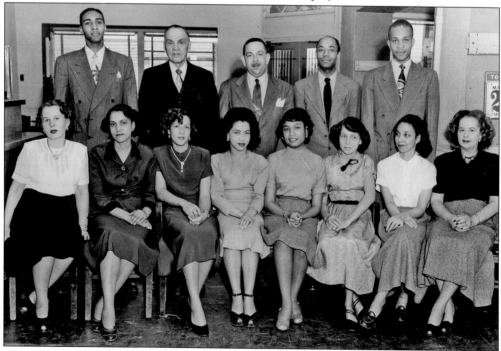

These dedicated 1950s employees were, from left to right, (first row) Mary Langston, Marie Todd, Shirley Spaulding, Edna Bolden, Patricia Young, Clara Richardson, Lucy Boone, and Thelma Jones; (second row) Drapher A. Pagan, John D. Chapman, Henry Sparks, Stephen Finch, and James Dunn.

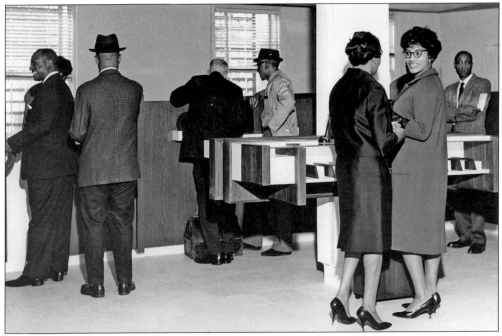

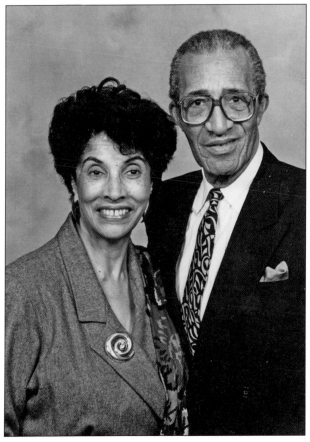

Winifred Lee (standing above right) was a loyal customer and neighbor of the bank. Lee and her husband, William, cofounded Lee's Flower and Card Shop in the 900 block of U Street in 1945. Rick, the couple's son, said his parents were account holders with Industrial even before they opened the business. He recalled: "I was a kid in 1950, and many times I would make the deposits for them." He most remembers the friendliness of Industrial's employees, saying, "They always treated me very nice. There would be long lines, and they would see me and call me up front to make my deposit. I'll never forget that." Above, Lee chats with bank board member Margaret Stewart whose husband, John, was the second generation of Stewart Funeral Home. The funeral home was started by his parents in 1900. Both businesses are currently operated by third and fourth generation family members. At left are Winifred and William Lee.

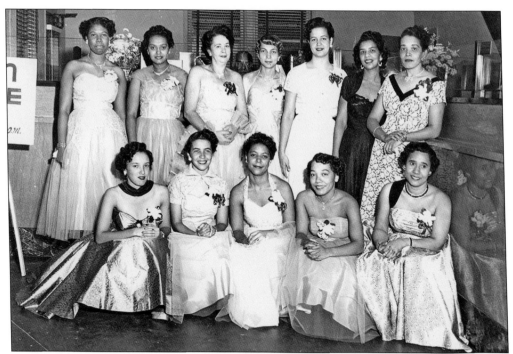

Industrial's female employees were playfully called "Parker-picked girls," said Mervin Parker, who did most of the hiring in the 1950s. Some of the women rose to higher positions at the bank. They included, from left to right, (first row) Virginia Rollins, Corrine Hammond, Douchia Brooks, Frances Johnson, and Zenobia Carter; (second row) Carrie Washington, June Taylor, Thelma Jones, Clara Richardson, Massie Fleming, Mary Mason, and Marion Brown.

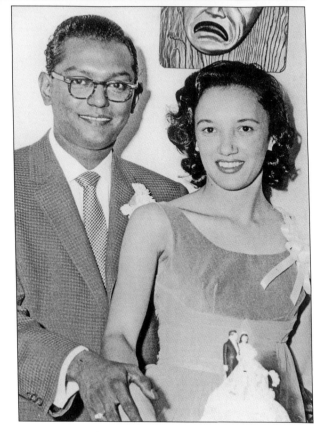

Ben and Virginia Ali, the founders of Ben's Chili Bowl, met at the bank. She was working as a teller and often waited on him, and as she recalls, "One day he wrote, 'Please call me' and left his number on a quarter wrapper." She never called, but a mutual friend later introduced them. She left the bank in 1958 to marry Ali and open the restaurant.

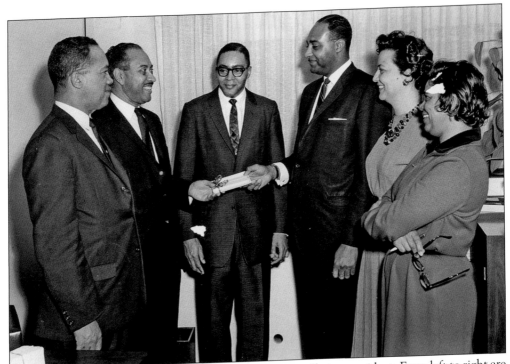

Bank officers congratulate Doyle on his 10th anniversary of being president. From left to right are Mervin Parker, vice president and cashier; Mitchell; Brownell Pagan, assistant cashier; Drapher Pagan, assistant cashier; Massie Fleming, public relations officer; and Ernestine Mann, auditor.

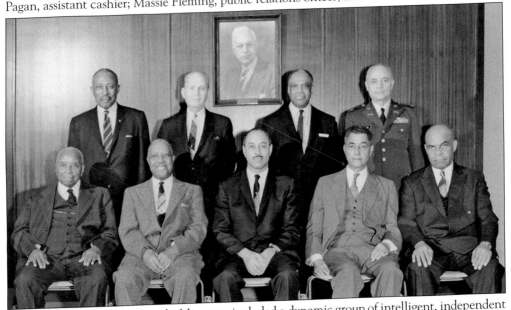

The bank's nine-member board of directors included a dynamic group of intelligent, independent thinkers who have made the crucial decisions that have enabled the bank to fulfill its mission. In the 1960s, the board included, from left to right, (seated) Isaac Mason, Thomas Parks, Doyle Mitchell, Talley Holmes Sr., and Dr. Henry Carmichael; (standing) J. Franklin Wilson, Dr. Robert Pearson, George E.C. Hayes, and Col. Campbell Johnson.

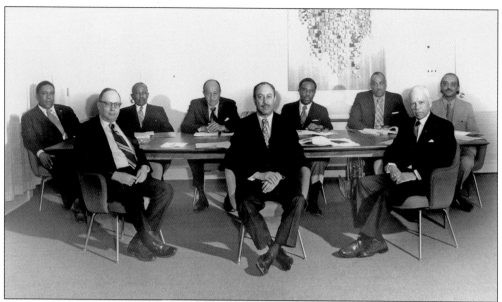

The board of directors has been crucial to keeping the bank operating efficiently. One of the 1970s boards included, clockwise from center, Doyle; George Windsor, attorney; Burkeley Burrell, president of the National Business League and owner of Burrell's Cleaners; J. Franklin Wilson, attorney; John Duncan, commissioner for the District of Columbia; Robert Madison, architect; John T. Stewart, second-generation owner of Stewart Funeral Home; Benjamin King, the first black certified public accountant in Maryland; and James Evans, a high-level federal government professional.

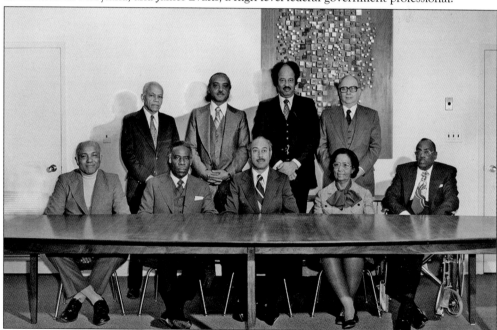

Another board of directors from the 1970s included, from left to right, (seated) Dr. Emerson Williams, Robert Madison, Doyle, Dr. Marjorie Parker, and John T. Stewart; (standing) James Evans, Benjamin King, John Thompson, and George Windsor. Dr. Parker, a North Carolina native and dedicated educator, was a true trailblazer, becoming the first woman named to the board.

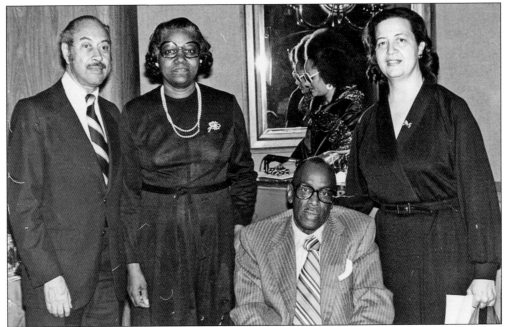

Evelyn Robinson (second from left), the board's recording secretary, rose to become a vice president. Also seen here are board members John T. Stewart and Massie Fleming. When Robinson was unsure of her title, she would turn to Massie and, she recalls, "I used to ask her, 'Massie, what am I?' She would say, 'You don't need no title! You're an assistant.' Massie was assistant vice president, and when people would ask me what I was, I would say, 'assistant to the assistant's assistant.' " Robinson was known for her great sense of humor.

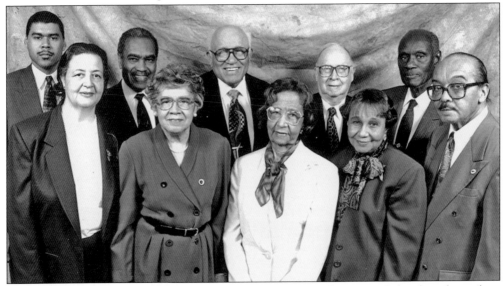

In 1989, Benson Doyle Mitchell Jr. joined the board for the first time. Other board members included, from left to right, (first row) Massie Fleming; Cynthia, Doyle Sr.'s wife; Dr. Marjorie Parker; Margaret Stewart, John Stewart's wife; and Benjamin King; (second row) Doyle Jr.; Clinton Chapman; Dr. Emerson Williams; George Windsor; and Robert White. Dr. Williams, who joined the board in 1975, remained a member until his death at age 92 in 2010.

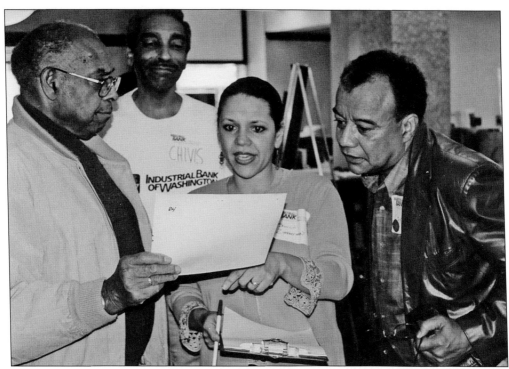

On a Saturday afternoon in 2008, many retired and former employees were invited to the bank to view photographs from the archives. The event was part of the bank's preparations for its 75th anniversary celebration. Sam Chivis and his son Martin, a longtime employee, examine a photograph with Sharon Zimmerman, the bank's marketing director. The Chivises are relatives of Industrial's first depositor, Lewis Johnson.

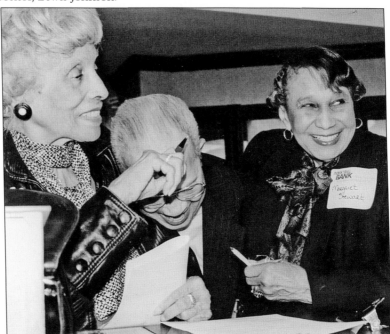

From left to right, longtime customer Winifred Lee, bank retiree Mervin Parker, and board member Margaret Stewart share a side-splitting laugh. The three had known each other for so long that they could probably have finished one another's stories.

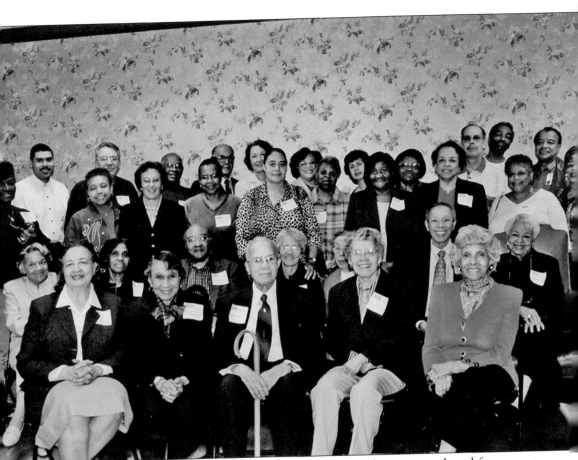

Before the evening was done, the Industrial family—old and young—gathered for a group photograph. They had spent the day laughing, swapping stories, and laughing some more. The memories and the common purpose they shared at Industrial will bind them forever. Elizabeth Hundley, who worked for Industrial for 35 years, recalled, "Working for Industrial Bank was a great experience, one that I will never forget. I have had the opportunity to work with the best coworkers and to meet customers that became my family. A bond was created that can't be duplicated." One of those close relationships was with Reta Brewer, an Industrial employee for 39 years. They traveled together and adopted each other's families as their own. When Brewer retired, she said, "Not one day did I feel unhappy about coming to work or dissatisfied." Brewer was passionate about saving. She established the Kiddie Trust for employees and friends to contribute money for their children's future. She would passionately demand donations for the Kiddie Trust and her favorite charity, St. Ann's Infant and Maternity Home.

Four

BRANCHING OUT

"During the 1950s and 1960s, the push for racial integration, as a means to an end, had an adverse effect on black banks, institutions, and many black businesses as many blacks enthusiastically patronized the white counterparts," says Cordell Hayes, former senior vice president. It was a paradox of the times and the loss of support was considerable as more and more blacks did business at white establishments. However, a great deal of blacks eventually felt disenfranchised by the "white flight" that ensued and the persistent racism of the era that caused blacks to embrace the growing Black Power Movement. This helped to sustain Industrial Bank at a pivotal time in its history.

By 1961, Industrial Bank was ready to stretch out. Black residents were moving to new areas of the city, such as Petworth, an area that bank executives decided was perfect for the bank's first branch.

Despite the changing demographics, businesses along Georgia Avenue, the neighborhood's main commercial strip, were still owned primarily by whites, who often refused to sell to black buyers. When Doyle and the board identified a site on Georgia Avenue, Dr. Robert Pearson, a light-skinned board member who could be mistaken for white—a so-called "straw"—negotiated the deal.

The board hired Robert T. Madison, a promising young architect, and dedicated $250,000—nearly $2 million in today's dollars—to transforming the old Deal Funeral Home into a state-of-the-art branch. In the meantime, the new Petworth branch opened in a temporary trailer in April 1962. By October 1963, the renovation was complete and the permanent branch on Georgia Avenue opened to much fanfare.

A month later, Madison was visiting Doyle at the bank when the men heard that Pres. John F. Kennedy had been assassinated. This came less than a month after the Sixteenth Baptist Church in Birmingham, Alabama, was bombed, killing four little girls. "We sat there in stunned silence," Madison recalled.

Life went on. Industrial built its next branch in Northeast from the ground up and opened it on May 31, 1966. That branch was named in honor of founder Jesse H. Mitchell. Three more branches opened under Doyle's leadership—one in the Frank D. Reeves Center at Fourteenth and U Streets, one on F Street in downtown Washington, and another at American University.

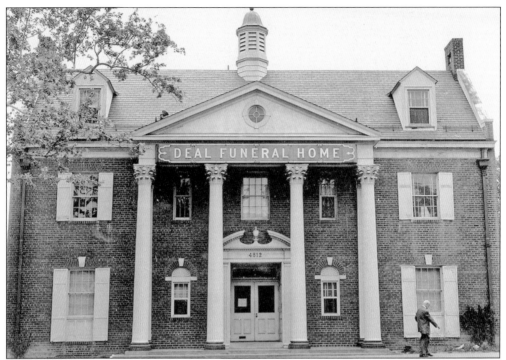

Architect Robert Madison was working as a lecturer at Howard University, his alma mater, when he heard that Industrial was planning to expand. A friend told him that the bank had just purchased some buildings on Georgia Avenue—the site of the old Deal Funeral Home—to remodel into a new branch. Madison, who had just started a practice in Cleveland and was traveling back and forth to Washington, submitted a packet and met with the board. He was thrilled to get the job. "I was so excited about it because it was my first major job," Madison said. "I did everything I could to make it the best that it could be." A house at Delafield Place and Georgia Avenue was razed, and the bank placed a trailer there to serve as the temporary branch while the buildings at 4810 and 4812 Georgia Avenue were remodeled. The trailer is seen below, next to the funeral home.

The new Petworth branch opened in a trailer in April 1962. Seen from left to right are an unidentified bank employee, Mervin Parker, Darlene Tinner, and Doyle inside the trailer. Mitchell chose Drapher Pagan Jr., who had started at the bank in 1949, as the new branch manager. "It was a big deal," Pagan said. "I was amazed because I had a staff, and I had a building . . . I was a proud young man when I was made branch manager." In the image below, Doyle (left) meets with Pagan (second from right) and two other employees in April 1962 to discuss the opening.

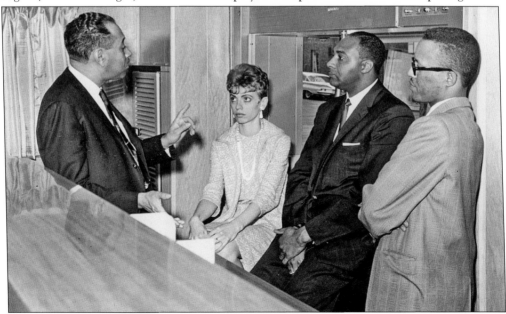

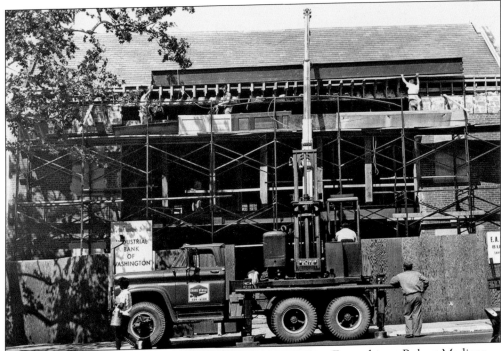

For architect Robert Madison, the project was extra special because the Deal Funeral Home had been designed by Howard H. Macke, one of his Howard professors. But converting a funeral home with an old Georgian front into a modern bank building was a challenge. "The funeral home had caskets lying all around, and so our first big step was to rebuild a frame for the front," Madison said. "We ripped out the entire front wall and replaced it with a glass wall." Other spaces were transformed and decorated with top-of-the-line furnishings. Madison also commissioned a special piece of artwork using enameled slices of metal. The finished building bore no resemblance to its former self.

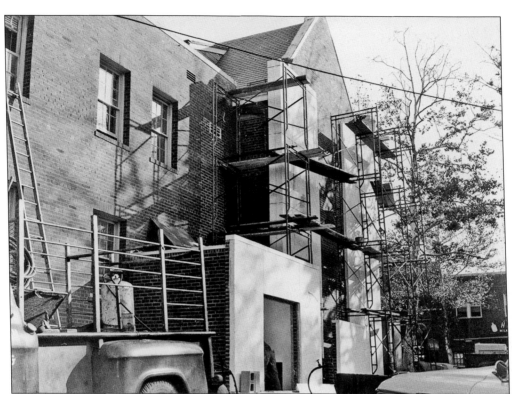

When the Petworth branch moved into its permanent location at 4812 Georgia Avenue in October 1963, the bank's leadership felt a huge sense of accomplishment. So, too, did the man who had turned their dreams into reality. "I think my happiest and fondest memory was the day we cut the ribbon for the 4812 Georgia Avenue location," Robert Madison said. "First of all, we got it built, and we built it for what we said it would cost, and it was beautiful. It was such a marked contrast from what it had been . . . And for Doyle, it was great because it was the first venture he did by himself, and all the great people who came were thrilled."

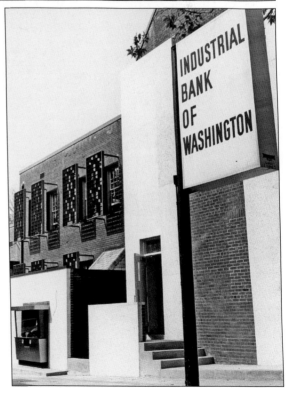

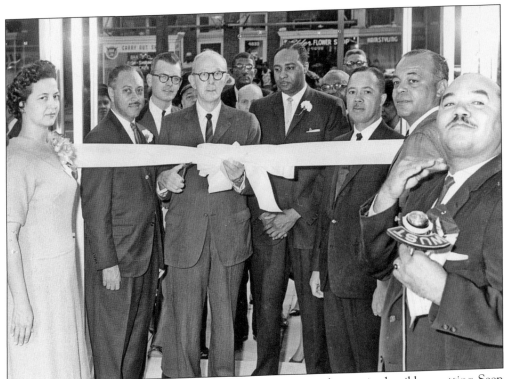

Above, District of Columbia officials joined bank executives and guests in the ribbon cutting. Seen from left to right are Massie Fleming, Doyle, an unidentified man, a city official cutting the ribbon, Drapher Pagan, Mervin Parker, Charles Fisher, and a television reporter. Below are, from left to right, Cynthia and Doyle, Mervin Parker, two unidentified people, and Mary Parker, Mervin's wife.

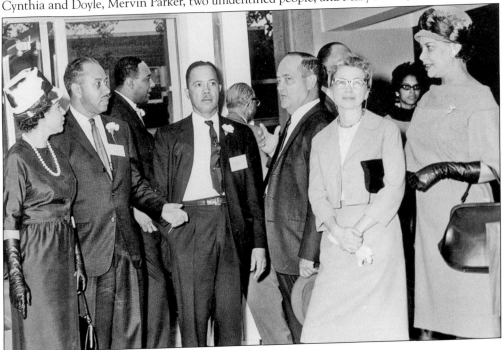

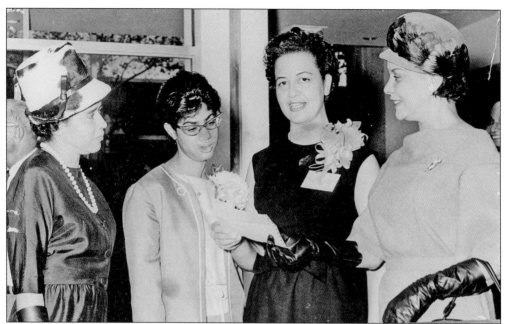

Mitchell family members and employees celebrated the branch opening, including, from left to right, Cynthia, Darlene Mitchell, Massie Fleming, and Mary Parker. The new building featured a stunning glass front entrance, which gave it a distinctive look. The bank's leadership could take pride knowing that the Georgia Avenue project had catapulted the career of a budding black architect. That was particularly important to Doyle, who had been taught by his father at a young age to network and support fellow black entrepreneurs. Robert Madison was grateful, saying, "There is no hesitation in saying that in selecting me as an architect to design the building it was the finest thing that had happened to me as an architect and my firm. I realized at that point that we had made it."

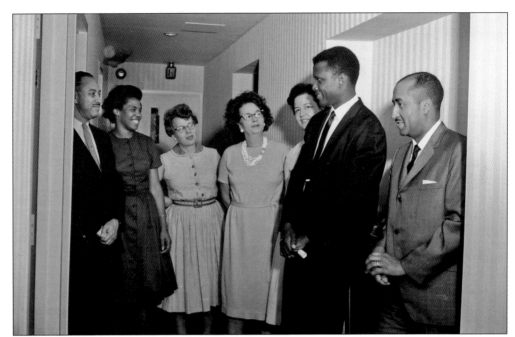

Bank employees and customers often looked up and saw celebrities among them in the bank. The bank's proximity to popular night spots, such as Bohemian Caverns, a jazz and blues club, often drew the rich and famous, including Tina Turner, Roberta Flack, Ella Fitzgerald, and Sidney Poitier, who is seen here with bank employees, from left to right, Doyle, Effie Faucett, Mary Langston, Thelma Jones, Massie Fleming, and an unidentified man.

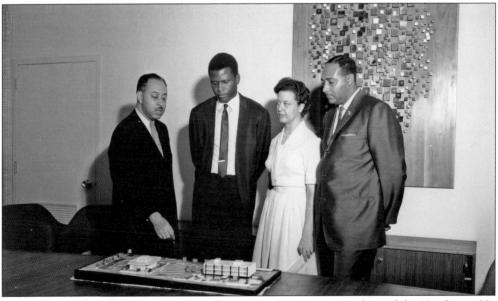

Poitier (second from left) got a sneak peek at an expansion project planned for Northeast. He is seen here with, from left to right, Doyle, Massie Fleming, and Drapher Pagan. Former board secretary and vice president Evelyn Robinson said this of the celebrities who made their way to Industrial: "This being the only black bank, and the fact that we were not always welcome in the other banks meant that a lot of people came to the bank that otherwise would not have."

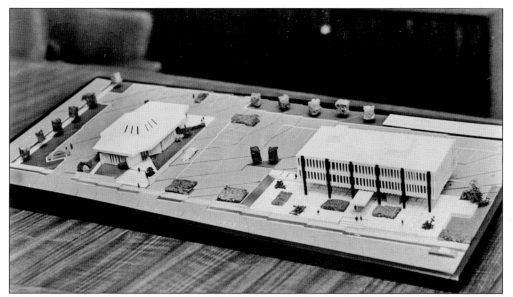

This model of the new Northeast branch gave a close-up view of the bank's next major project. This time, the expansion would occur in the far northeast corner of the city, at Forty-fifth and Blaine Streets near Benning Road. Benning Road was a heavily trafficked area, and the black population was beginning to stretch out in that direction. Once again, Madison was hired to design the project. His challenge this time was to transform a huge vacant lot.

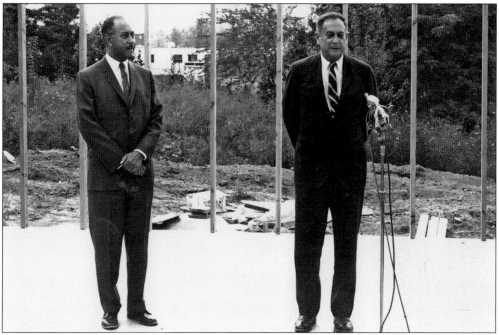

Doyle and a city official addressed the crowd of employees and supporters who had gathered for a groundbreaking on the site of the new Northeast branch. The board had decided to name the new building the Jesse H. Mitchell Branch in honor of the bank's founder. Robert Madison was thrilled for the opportunity to design such a special project. "It was very exciting to do something like that," he recalls.

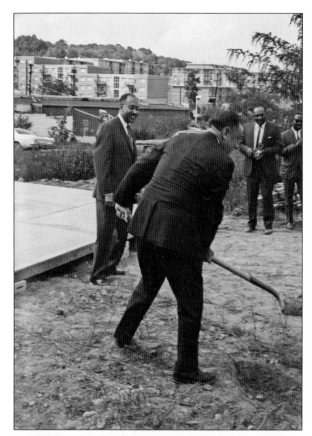

The groundbreaking for the new branch was a special moment for the community. "It was a new beginning," Robert Madison said. "This was the first African American branch of a bank in that area to serve the people, and there was a big celebration. Of course, Doyle was on cloud nine. All of us were on cloud nine. It was an investment in the future, and the excitement was high." (Both, courtesy of SI.)

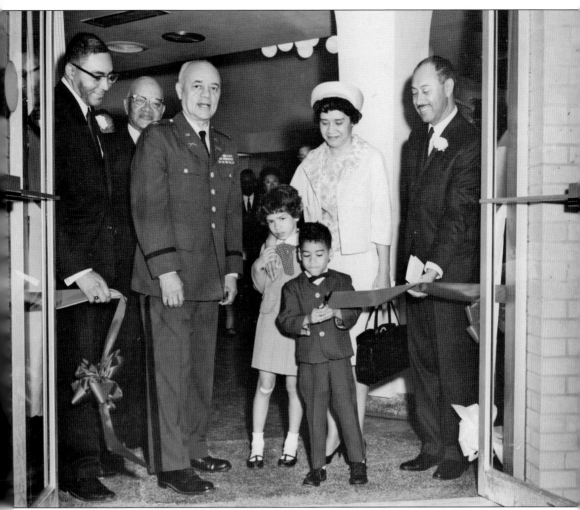

Drapher Pagan's younger brother Brownell was chosen to manage the Northeast branch, which opened for business with a grand celebration on May 31, 1966. The new branch expanded Industrial's reach even deeper into the city. The community had been hungry for a bank and neighbors responded enthusiastically. Seen here are, from left to right, Brownell Pagan, the new branch manager; James M. Nabrit Jr., Esquire, former president of Howard University; Col. Campbell Johnson; and Cynthia, with Patricia, Doyle Jr. (cutting the ribbon), and Doyle.

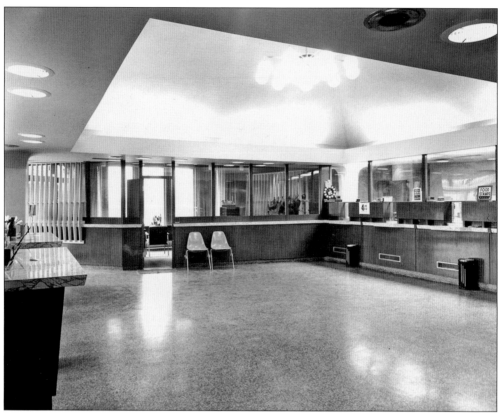

The branch lobby was open and spacious to accommodate the many anticipated customers. On opening day, the community came out to show its support.

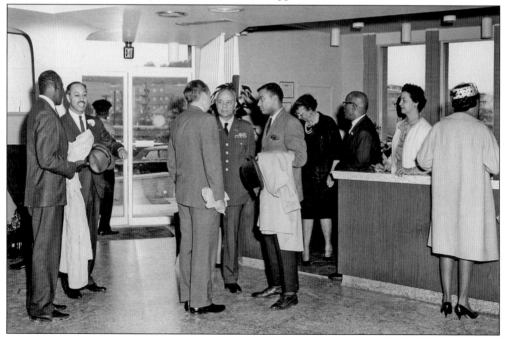

Few people attending the grand opening of the Northeast branch were more excited than Brownell Pagan, who had been chosen to manage the new branch. In the above image, he awarded a new clock radio to a customer as a door prize. Below, an Industrial employee greeted Dr. and Mrs. Robert Pearson. Dr. Pearson's fair skin had enabled him to act as a "straw" to purchase the Georgia Avenue properties.

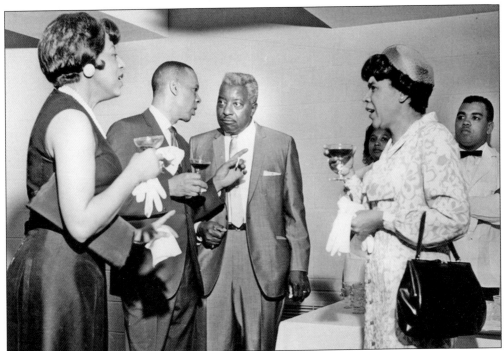

A proud Cynthia (right), holding her wine glass, mingled with the guests. Dr. Flavius Galiber (second from left) was a longtime friend of the bank and the Mitchell family.

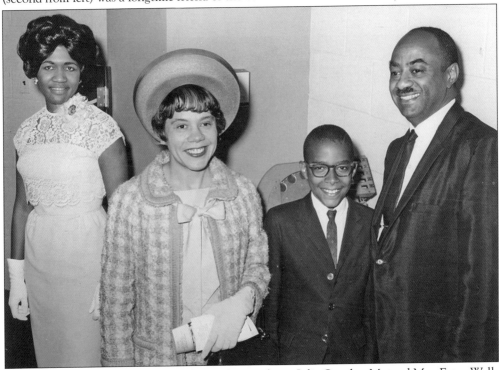

Among the celebrants were, from left to right, employee Julia Quarles, Mr. and Mrs. Estee Wells and their son.

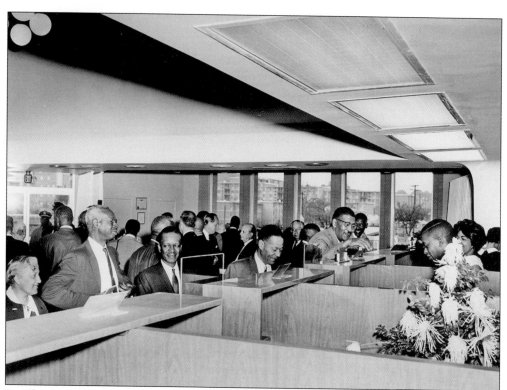

Finally, the Jesse H. Mitchell Branch of Industrial Bank of Washington was open for business.

In 1986, Industrial opened another branch at the suggestion of Mayor Marion Barry at the intersection of Fourteenth and U Streets in the Frank D. Reeves Municipal Center. Barry had pushed to build a center that would house various government agencies and retail establishments and spur economic development on U Street. The neighborhood had declined sharply after the 1968 riots and the influx of drugs. Although it took many years, the mayor's plan eventually succeeded.

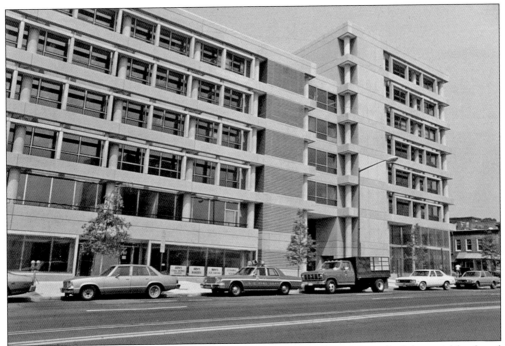

The Reeves Center played an important role in the eventual turnaround of the neighborhood around Fourteenth and U streets. It was the first major building to be constructed on U Street in decades, and it brought hundreds of jobs and the need for more economic development. "The customers were waiting for us to come because there was no bank in that neighborhood. The merchants needed the convenience of a bank in that community," recalled 35-year employee Elizabeth Hundley. "We were greeted with open arms."

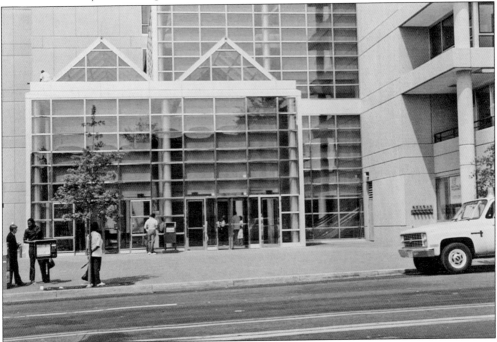

Board member Waddell Thomas (above left) participated in a reception celebrating the opening of the Reeves Center branch. Other guests included Talley Holmes Jr. (below right), whose father had been a member of Industrial's original board, and board member George Windsor (below left). In the image at right, Holmes greets Windsor.

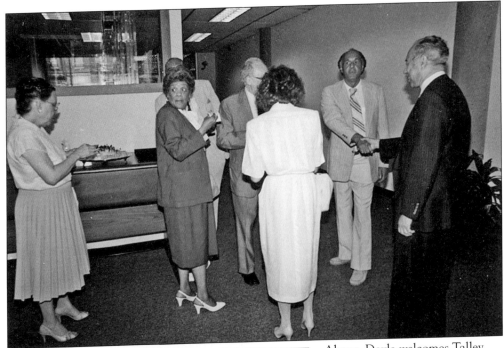

Above, Doyle welcomes Talley Holmes Jr. The fathers of both men had been close friends and business associates. Talley Holmes Sr. was a realtor who granted second mortgage loans to customers who needed extra help. Holmes Jr. recalled this about his father: "He would stand out on the side of Industrial Bank as the people came in and he'd make his deals on the outside of the bank." Longtime employees Daisy Sewell (far left) and Hallie Campbell (second from left) were employees for 31 and 37 years, respectively.

In February 1991, Industrial finally ventured downtown and opened a branch on F Street. Doyle had always wanted a downtown branch, and so the opening of this branch meant a great deal to him. Downtown Washington represented wealth and power. Doyle saw Industrial's presence there as a sign of success.

Above, Cathy Hughes, founder of Radio One, including the popular WOL 1450AM, joined the Industrial family in celebrating the opening of the downtown branch. Below, also celebrating the opening were, from left to right, Leslie Hayes, Cynthia Mitchell, Drapher Pagan, and Shirley Miller.

The event included entertainment for kids of all ages.

The first customer of the downtown branch opened an account with bank employee Lela Smith. Lela was an employee for 22 years.

Five

CELEBRATING MILESTONES AND SUCCESSES

Industrial Bank loves to celebrate milestones. Every anniversary and every honor represents survival. Industrial survived the ground-shaking tumult of the 1960s, with the assassination of black heroes, particularly Dr. Martin Luther King Jr., and the anger that exploded in the streets just outside the bank afterward.

"When Dr. King was assassinated, the city went up in flames," Virginia Ali recalled. She was in her restaurant down the street from the U Street branch on April 4, 1968, when someone ran in and shouted that King had been shot. "We turned on the radio, and were listening, and then we hear the news that he has died. Well, everyone starts crying. It's just a horrible, horrible, sad moment in our lives, and then out of frustration some youngster throws a brick at the drugstore at Fourteenth and U. It just escalated from there . . . It was just an awful time."

Twelve people died in the riots, more than a thousand were injured, six times that many were arrested, and dozens of buildings that had been torched were left abandoned. Industrial and a few other black businesses emerged unscathed. But U Street, the city's black diamond, whose sparkle had attracted the rich and famous from around the world, became for decades a hub for drugs, prostitution, and other crimes.

Industrial also survived the construction of Metro's Green Line, which started in 1986 and dragged on for five years. "It was very devastating to the U Street business community. Most of the small businesses along U Street were not able to sustain the construction that prevented access to their business. U Street, a major thoroughfare, was closed for much of that time. The businesses that survived were Industrial, Lee's Flower Shop, Ben's Chili Bowl, and Egber Liquors," Patricia recalled. Businesses were left covered in dust and grime, and all but the most loyal customers avoided the area. Most small businesses in the area were forced to close.

Today, Industrial is still standing and grateful for every milestone.

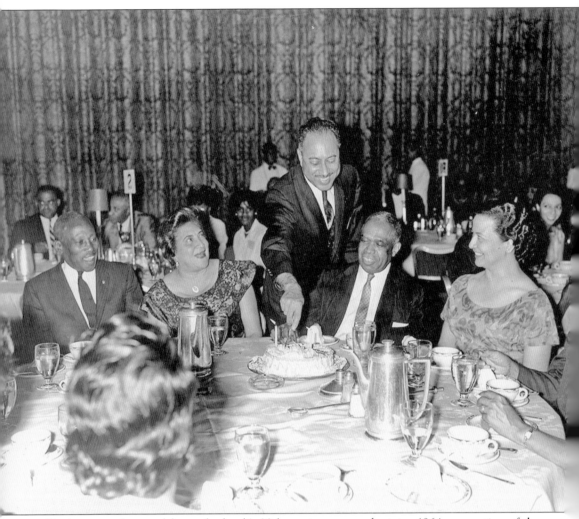

Doyle cut a cake to celebrate the bank's 30th anniversary at the joint 1964 convention of the National Bankers Association, the trade association for minority banks, and the National Business League, which was founded by Booker T. Washington in the early 1900s to promote black business ownership. Seen here are, from left to right, J. Franklin Wilson, Mrs. George E.C. Hayes, Doyle, George E.C. Hayes, and Massie Fleming. Doyle followed in his father's footsteps, serving in leadership roles in both groups.

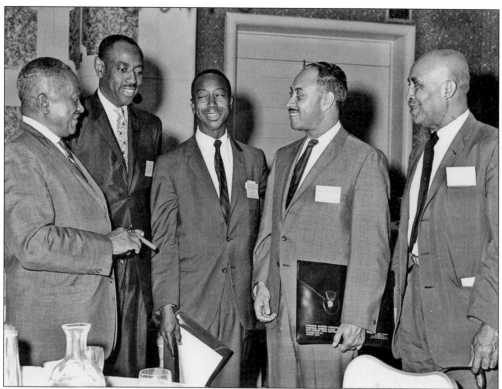

Doyle, fellow bank employees, and friends enjoyed the 1964 joint convention of the two business groups, something that rarely takes place today. For 30 years, Industrial was the only black-owned, black-operated bank in the District of Columbia.

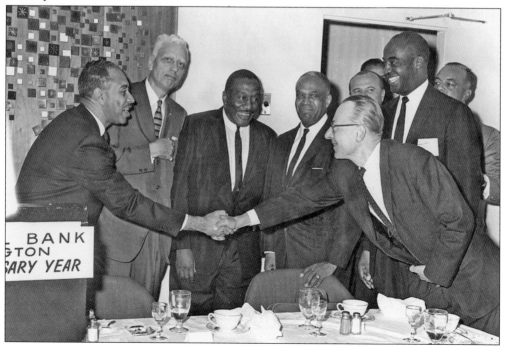

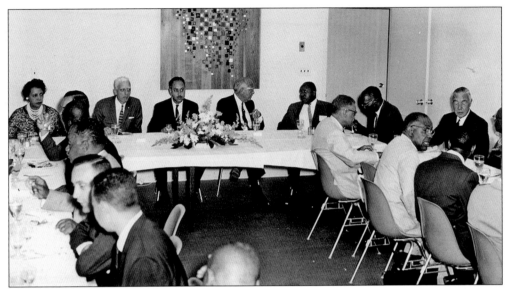

Members of the National Bankers Association hold a meeting at Industrial. Doyle Mitchell served as president of the group from 1959 to 1966. This photograph shows a female banking executive, a rarity in the early days of banking. According to the association, an African American woman, Maggie Lena Walker, became the first woman in the country to charter a bank in 1903, when she started Saint Luke Penny Savings Bank in Richmond, Virginia.

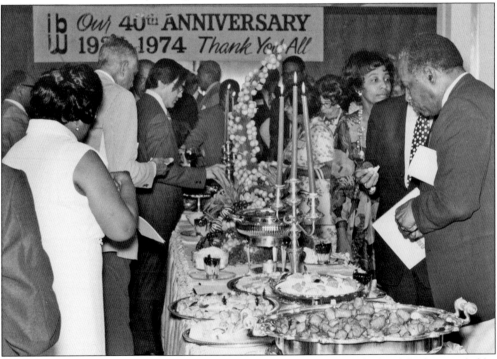

By their 40th anniversary in 1974, Industrial had much to celebrate. The bank had expanded by adding two additional branches: the Petworth branch, which in 1969 had become the main office, and the J.H. Mitchell branch in 1966. The bank's resources had grown to $41.48 million. In this photograph, employees and guests took part in a feast prepared for the anniversary celebration.

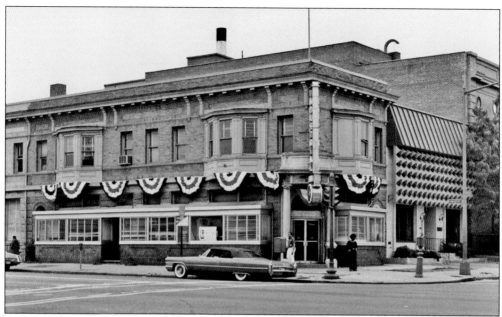

Industrial's original site at Eleventh and U Streets and the Petworth branch on Georgia Avenue were draped in red, white, and blue in recognition of the bank's 40th anniversary. Robert Madison, the architect of the Petworth and Northeast branches, who also served on the board of directors for a time, knew that the bank brought everyone associated with it much pride, saying, "There was so much pride that this was a black-owned bank and they had adopted the same kind of traditions and professionalism of other banks . . . We had the usual problems, of course, but the bank still survived and thrived and still does today."

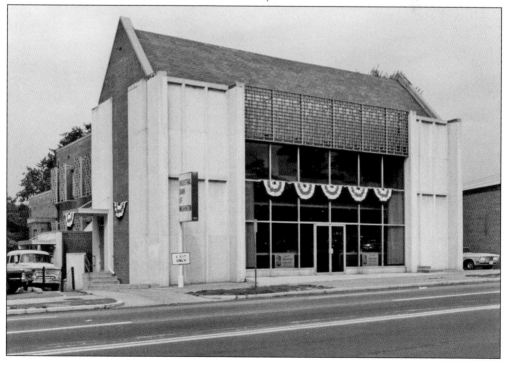

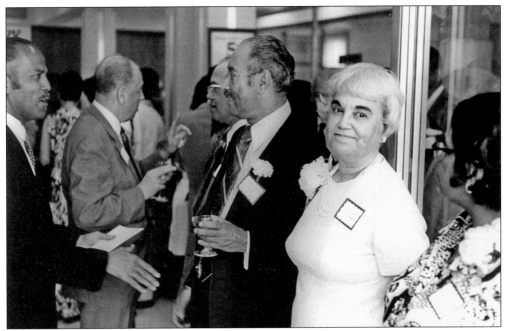

Doyle enjoyed the anniversary with dedicated employees Ernestine Mann (far right), Mary V. Boyd (second from right), and Conrad Martin Jr. (far left), an employee whose father was president of First State Bank in Danville, Virginia, another black-owned bank.

Mervin Parker (far left), a longtime executive at Industrial and close friend of the Mitchell family, greets a customer at the anniversary celebration.

Mervin Parker and his wife, Mary, greet a friend. In the foreground is a young Doyle Jr., the future bank president.

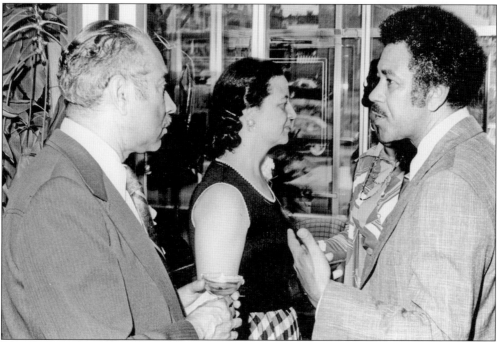

Doyle and Massie Fleming chatted with fellow banker William Fitzgerald, who started Independence Federal Savings Bank, another black financial institution in Washington. Fitzgerald said he considered Doyle a mentor.

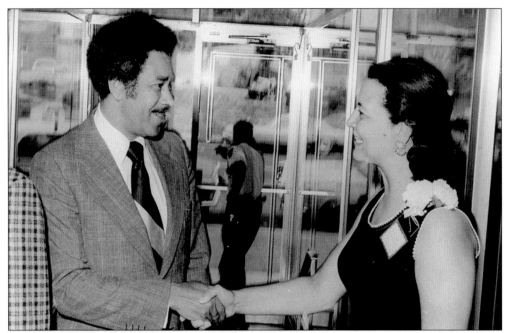

Banker William Fitzgerald, shown above, later told the *Washington Post* in a 1993 story that "Doyle Mitchell was a jewel, a gentleman. There have been 30-odd financial institutions that have gone out of existence in this city over the last decade . . . Industrial Bank is still here. This man brought it through tough times and held it together, and today it is prosperous and sound. It is a tremendous legacy."

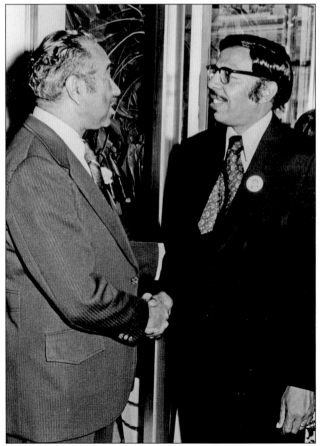

Among the celebrants at the 40th anniversary celebration were Rev. Jerry Moore, former pastor of Nineteenth Street Baptist Church and a former member of the city council. From the beginning, churches were the bank's strongest supporters.

Doyle got a congratulatory kiss from his mother-in-law, Larkie Thompson, who joined the anniversary festivities and mingled with guests.

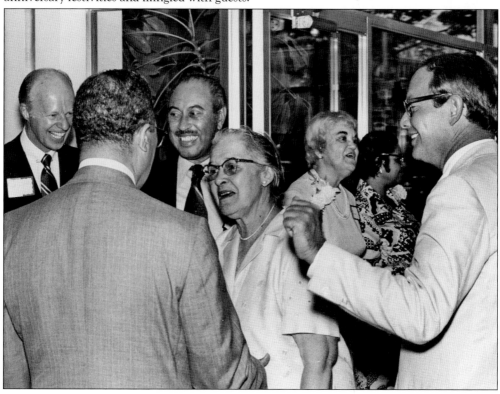

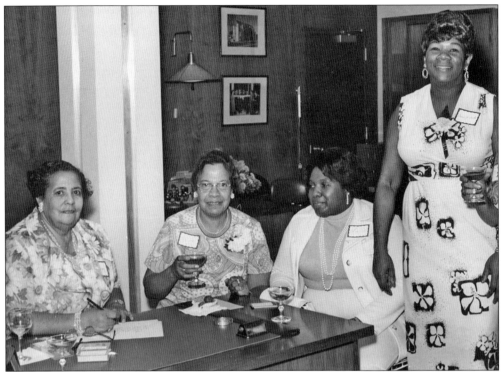

Above, from left to right, employees Marguerite Gregory, Celeste Mills, Shirley Miller, and a unidentified woman toasted the bank's success. Below, a large group of employees helped to make the event a momentous occasion.

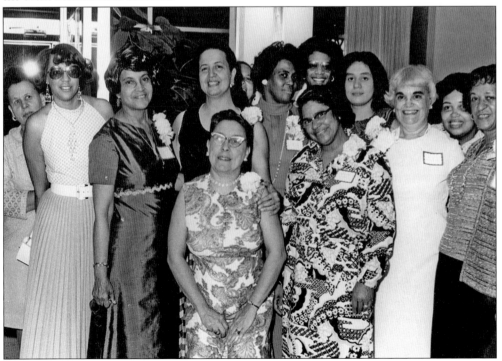

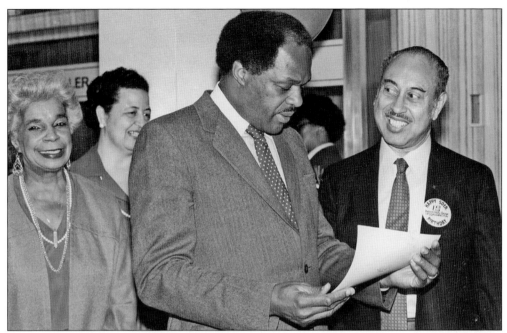

A four-day celebration in 1984 marked Industrial Bank's 50th anniversary. The bank's sheer survival was a testament to the solid leadership of two generations of Mitchells. In 1984, the bank's resources totaled more than $70 million. Mayor Marion Barry (above center) was among the public officials who joined the bank's executives, employees, and guests in the celebration. Mayor Barry read a proclamation congratulating Doyle on the bank's anniversary. Barry later assisted in cutting the cake, surrounded by, from left to right, board members Benjamin King, Clinton Chapman, Doyle, and Robert White.

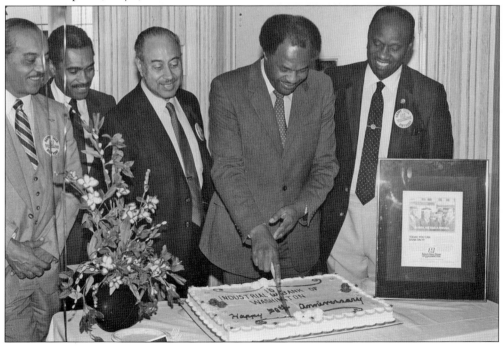

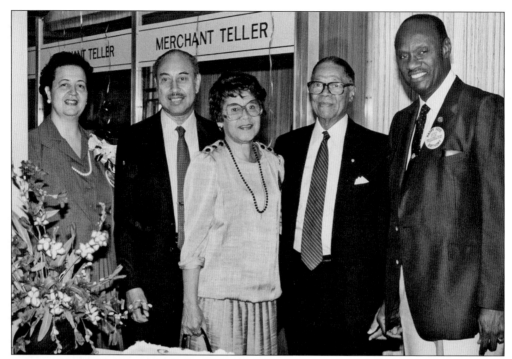

Some of the bank's leaders posed in front of the 50th anniversary cake, including, from left to right, Massie Fleming, Doyle, Cynthia, and board members Reginald Washington and Robert White. Customers young and old joined the bank in celebrating 50 years of success.

Here, Doyle laughs with vice president Effie Faucett, who worked for the bank for 47 years. Many future young bank executives first came through her shop, including Doyle Jr. Faucett was his first boss when he joined the bank.

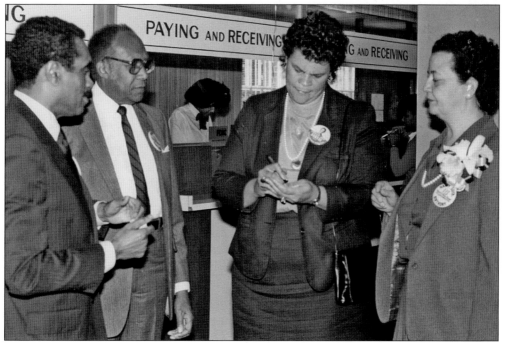

Charlene Drew Jarvis (second from right) joined Massie Fleming (far right) and board members Clinton Chapman (far left) and Waddell Thomas for the event. Jarvis was the city council representative for Ward 4, where the Petworth branch is located.

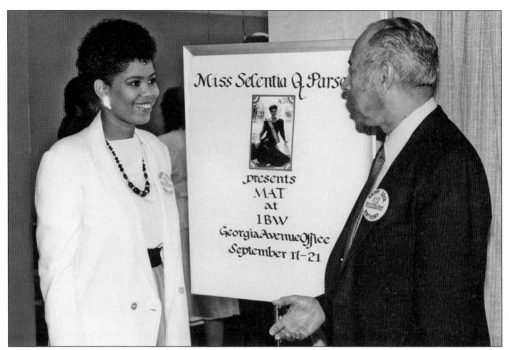

Employee Selentia Q. Parson, "Miss Shrine USA" from 1982 to 1983, was also on hand to greet guests. She is seen here chatting with Doyle.

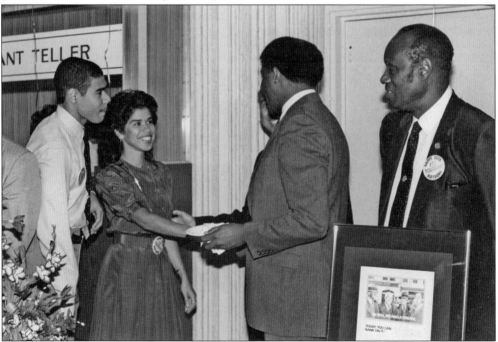

Mayor Marion Barry congratulated Patricia and Doyle Jr., the future bank leaders. The siblings remember their father working long hours at the bank. Their mother also had a significant role in the bank's success, they remember. "How she supported him and what she meant to my father allowed him to do what he did," said Doyle Jr.

Christmas parties, picnics, and other celebrations were a regular part of life at Industrial. Here, employees Lorraine Washington and Martin Chivis share some holiday cheer.

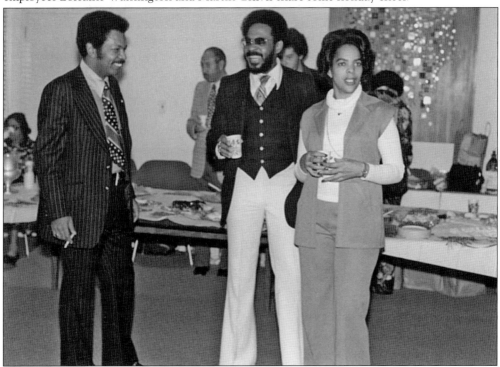

There was always a chance to get down. Employees Terrance Blount (left), Claude Barrington (center), and Janice Hawkins got in on the fun. Those white bell-bottom pants were considered cool back then.

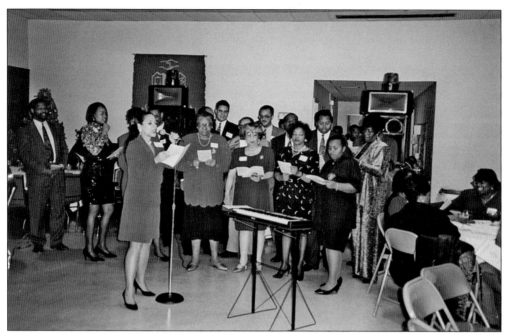

For several years, Industrial employees produced their own entertainment for the Christmas party. Led by Sharon Zimmerman, bold employees, many of whom sung in their church choirs, graced the evening with song. Other activities included raffles for door prizes and service awards.

The bank's Christmas parties eventually became so large that in later years they had to be scaled back. They were at their best, of course, on the dance floor. Popular local musicians played from time to time, such as Spur of the Moment and Marcus Johnson.

Picnics were also on the bank's social agenda most summers. Here, at one of the summer events in 1965, Doyle speaks with Ernestine Mann, an auditor at the bank. He was in a rare tennis shoe moment.

Employees and their guests also participated in competitive games, including basketball and volleyball. The picnics also included swimming.

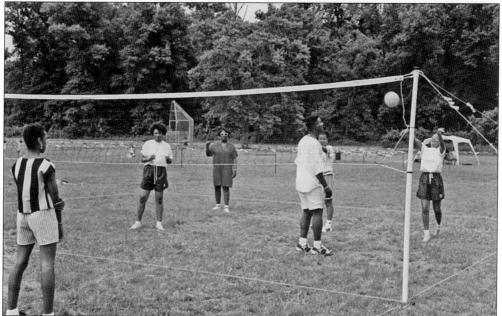

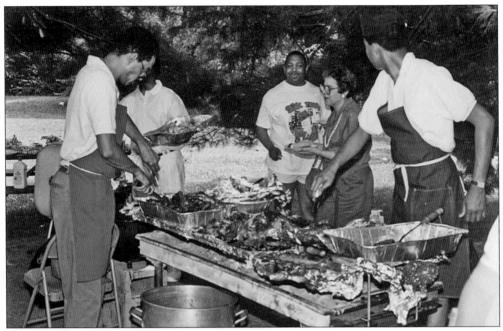

The food for the picnics was never catered. Employees did all the cooking. Here, bank employee Roy Moss carved, while Sam White and Cynthia Mitchell walked off with plates. Attendance at the picnic grew at one point to nearly 250 people. Children were always welcome, and one of their favorite activities was the Moon Bounce. Garfield Vann, not pictured, was the chair of "his" picnic committee each year. Dee Mance, a 34-year employee who is still with the bank, has "built friendships with customers and employees over the years that continue to grow."

Jesse Mitchell was posthumously inducted into the Washington Business Hall of Fame in 1990. The award recognizes individuals for the tremendous impact they have made through business excellence on the growth and character of the Greater Washington region. The entire Mitchell family was present. Here, Doyle is joined by his great-nephew and great-niece, Cordell Hayes Jr. and Joigie Hayes.

Six

CONNECTING TO COMMUNITY AND CUSTOMERS

Industrial owes its livelihood to black Washington. From the beginning in 1934, men and women raided their piggy banks, pulled dollars from shoe boxes and mattresses, and passed around the collection plate in their churches to buy stock and help open the new bank. Ever since, the bank and its community have been inseparable, and their relationship has been based on mutual need, respect, and appreciation.

The early customers were people like Dr. Victor Assevero, who moved to Washington from Trinidad in 1944 to attend Howard University. He had $1,400 to his name, and Industrial was the only bank in his community. He opened an account, received competent, friendly service, and never felt a need to go elsewhere.

Albert Burke had been one of the buffalo soldiers—the first all-black regiments in the US Army—when he moved to Washington after World War II to attend Howard University. His new wife, Mary Johnson Burke, was related to Lewis Johnson, the bank's first depositor. When the Burkes needed financing for their first and second cars, they turned to Industrial. "The environment was very friendly and welcoming," Burke remembers. "The bank was a real part of the community."

In some cases, customers trusted bank employees like family. While working as a teller at Industrial in the 1950s, Virginia Rollins Ali often encountered her customers after hours on U Street. Occasionally, one of them handed her some crumpled bills with a special request. She recalled them saying, "Oh, I'm so glad I ran into you, Miss Rollins. Could you put this in my account tomorrow?"

Through the years, the bank has responded in kind, treating all customers with the dignity they deserve. The bank has improved its facilities and services for the comfort and convenience of customers, provided loans to churches and individuals when others would not, helped couples buy homes, assisted entrepreneurs in starting their businesses, and donated countless volunteer hours, money, and other contributions to places and causes important to the community.

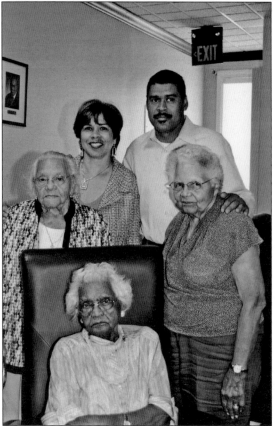

Alyce Dixon started her account at Industrial Bank of Washington in 1934 with $65. "I figured they were trying to make a go of it," she said in 2011, explaining why she trusted the bank after losing most of her savings when the earlier bank closed. Bank employees Melanee Woodard (left) and Patricia (right) visited Dixon, then 103, at a nursing home operated by the Washington, DC, Veterans Administration Medical Center.

In 2010, Doyle Jr. and Patricia met with three sisters who have been longtime customers. From left to right are (seated) Margaret Harris, then 95, a self-employed dressmaker; (standing) Inez Dade, then 97, the owner of Tiny Tot Day Care; Patricia; Doyle Jr.; and Vanilla Beane, then 90, who owns Bene's Millinery and made the late Dorothy Height's famous hats by hand. The sisters and Dade's daughter Helen Felton all opened accounts in the 1950s.

Patricia (holding son Julian) posed with civil rights and women's activist Dorothy Height, the former president of the National Council of Negro Women (NCNW), who was wearing one of her signature hats. On her first day of office in 1957, the panicked new president called the bank after learning that a loan the organization had taken out was due. The matter was resolved quickly, and the NCNW remained a loyal customer.

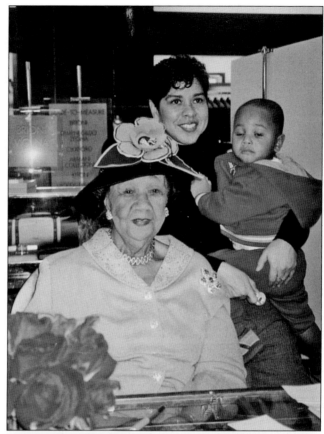

Lee's Flower and Card Shop has been a longtime U Street neighbor and customer of the bank. Seen here are, from left to right, Stacie Lee Banks, granddaughter of the founder and who runs the business; her husband, Jeffrey Banks; and her father, Rick Lee, whose parents were the founders. The fourth generation of the Lee family also operate the business.

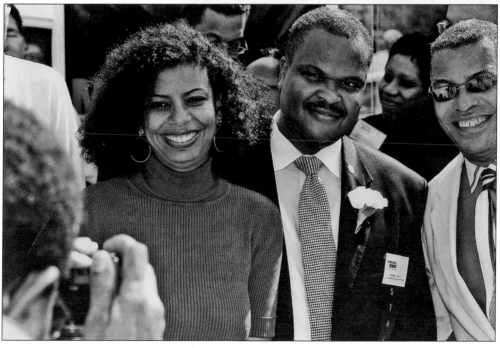

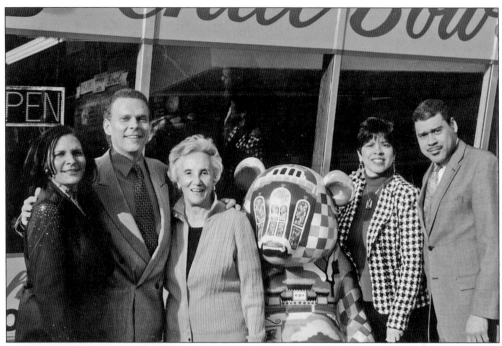

The children of jazz great Duke Ellington—April and Edward Jr. (at left)—stand with, from left to right, Virginia Ali, Patricia, and Doyle Jr. outside Ali's famous U Street restaurant, Ben's Chili Bowl. The legendary bandleader and composer grew up in Washington and helped U Street clubs gain prominence as significant venues for black entertainers.

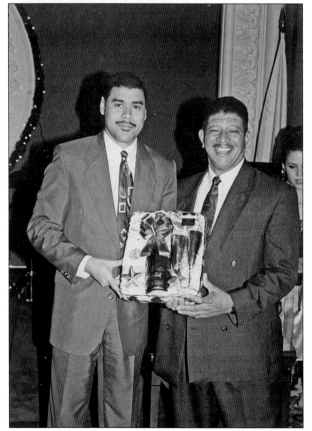

When Chuck Royster (right) turned to Industrial 25 years ago, he needed a $50,000 loan to cover the payroll for his small information technology business. He was awaiting funds from a government contract, and other banks had turned down his loan application. His parents were customers at Industrial, which granted the loan. Royster's business grew into a $20-million operation with nearly 300 employees. He is shown here with Doyle Jr.

A construction loan from Industrial enabled developer and attorney Tony Barros (second from right) to build this two-story center at Twelfth and U Streets. The building houses retail stores and restaurants on the first floor with offices upstairs. The project helped spur economic development in the community as part of the revitalization of U Street in the late 1990s. From left to right, Patricia is seen here with Tina Carter, a commercial loan officer; Barros; and Lewis Williams, a former commercial loan officer.

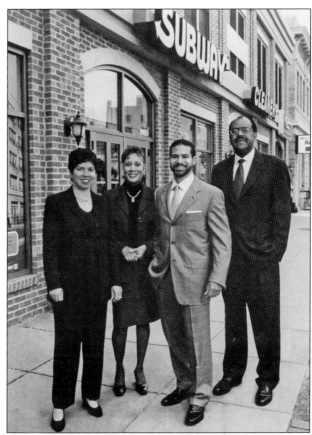

Ron Adolph, the president and chief executive officer of TAC Transport, got the first loan for his waste transportation company from Industrial in 2001. His company has since grown into an operation with revenues of more than $30 million. He and Patricia stand in front of his trucks.

The Stoddard Baptist Home Foundation, founded in 1902, and Industrial have a long history; both respect and support each other as community organizations. About the time that the organization was planning a new venture, Patricia happened to see Steve Nash, Stoddard's CEO, in the airport. The two chatted, and Industrial ended up providing Stoddard a loan to help set up the new entity. Standing next to a sign for the facility are, from left to right, Mahesh Tyagi, chief financial officer for Stoddard; Doug Dillon, commercial loan officer for the bank; and Steve Nash, president and chief executive officer for Stoddard.

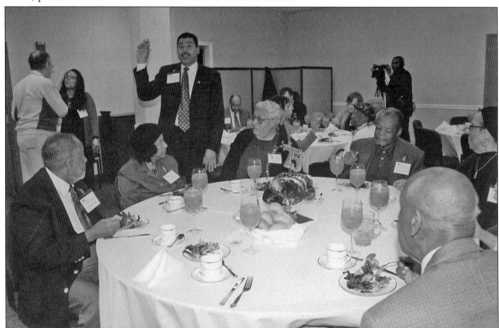

In recognition of its 75th anniversary, Industrial hosted luncheons for customers over 75 years old. Doyle Jr. suggested the luncheons as a way to thank longtime customers. Employees researched and identified more than 200 men and women, including several former employees, to be honored.

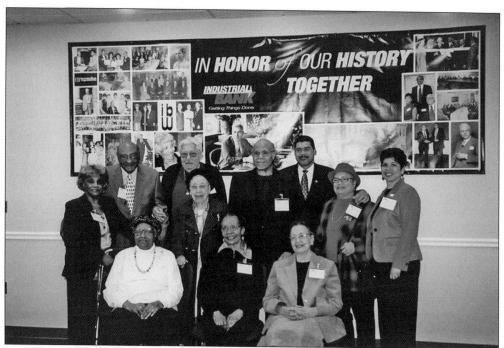

Doyle Jr. and Patricia are photographed above with longtime employees and customers.

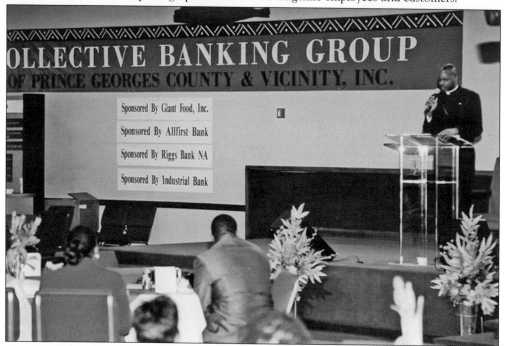

A group of black pastors formed the Collective Banking Group in 1993, when they met to discuss inequitable access to banking services. The group (later the Collective Empowerment Group) elected one of its founding members, Rev. Jonathan Weaver, pastor of Mount Nebo African Methodist Episcopal Church, as its first president. Members signed a covenant with four banks, including Industrial, which promised to provide favorable services to the minister's members.

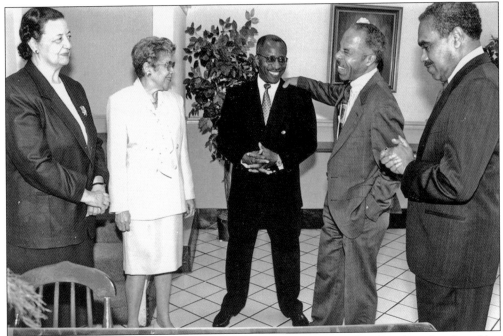

In the 1990s, George Haley opened an estate account for his late brother, famed author Alex Haley, whose groundbreaking novel *Roots* traced an African family from their capture in their homeland through the Middle Passage to the American South. It became a riveting television series. Haley (second from right) was greeted by, from left to right, Massie Fleming, Cynthia Mitchell, commercial loan officer Jim Sherard, and board member Clinton Chapman.

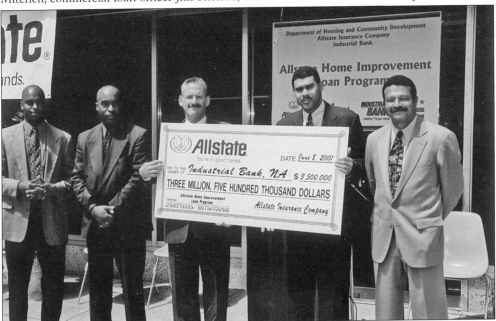

Doyle Jr. holds an oversized check for $3.5 million from Allstate as others, including Milton Bailey from DC Housing Finance Agency, look on. The company partnered with Industrial to provide home improvement loans to inner-city residents.

Bank employees enjoy volunteering in the community, especially in local schools. They have discussed banking jobs at Career Day events, such as the one above, and made presentations on saving, budgeting, and the importance of good credit. Employees even developed and taught a structured curriculum for the finance academy at a local high school to teach students how to develop a personal budget and how to plan for financial emergencies. The bank also sponsors financial empowerment seminars on a variety of topics, such as home ownership, credit, and marketing.

Industrial employees value the opportunity to help members of the community achieve their dream of home ownership. To help educate potential homeowners about the process, bank employees have participated in periodic housing fairs sponsored by a variety of large nonprofit groups that provide free counseling to mortgage borrowers. The fairs offered a variety of vendors and experts to educate participants on every step in the home-buying process.

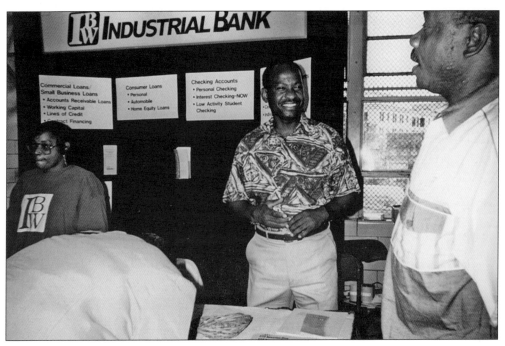

Industrial employees believe in the importance of financial literacy and spend countless hours in local schools helping to educate the next generation about money and how their financial choices can have a positive or negative impact on their lives. Here, Industrial employee Lloyd London talks to students about credit.

From the president of Industrial on down, all employees are encouraged to participate in the community. Here, Doyle Jr. lends a hand in a school cleanup. Doyle said his parents kept him and his sister grounded as children, and they often did volunteer work in the community.

One of the bank's favorite projects has been establishing kid banks in several schools to teach students about the value of money and banking. Bank employees set up a "children's bank" shop in the schools once a month, and students collect money that their fellow students have saved for deposit. The bank employees oversee the transactions, transport the money to the bank, and deposit the funds in the children's accounts.

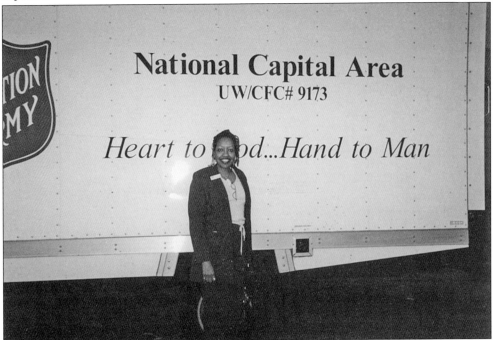

The clothing drive for the Salvation Army's National Capital Area always draws an abundance of donations from employees and customers.

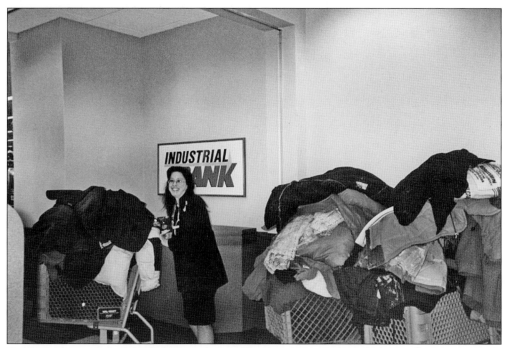

Employees oversaw the huge Salvation Army effort aimed at providing clothes and other necessities to the area's homeless men, women, and children.

Industrial has regularly partnered with other groups to sponsor community programs, such as this event featuring area musicians.

Industrial sponsored the recent event above, which also featured local musicians.

On September 18, 2010, Industrial sponsored its first annual Author and Artists Showcase, which brought some of the community's most talented painters, craftsmen, writers, and other artists to the neighborhood. In a large tent set up in the parking lot across from the Eleventh and U Street branch, neighbors got to mingle with the artists, buy their wares, and hear them speak about their work. Among those who participated was local artist Susan Jarvis Ragland (seated).

The showcase was the brainchild of Patricia, who said her own appreciation for the arts led her to create a forum that would bring together a variety of local artists. Among those she invited to participate was Lisa Frazier Page, coauthor of the *New York Times* bestselling book *The Pact: Three Young Men Make a Promise and Fulfill a Dream* and *A Mighty Long Way*, a memoir written with Carlotta Walls LaNier, the youngest member of the Little Rock Nine.

The artist's tents at the showcase were a big draw as they enabled locals to showcase their talent and sell their work.

Guests also flocked to the tables featuring books and greeting cards. Seen here is Lori Nelson Lee, the author of *Hilary's Big Business Adventure*. This event has drawn many community residents and other patrons.

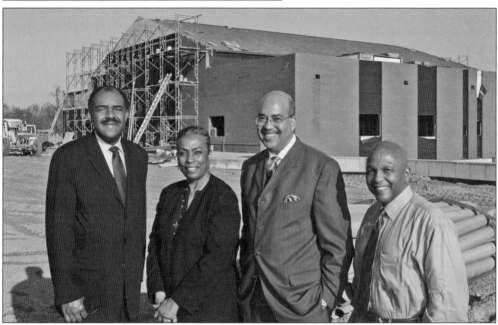

Industrial continues its legacy of financing faith-based organizations. Greater Mt. Nebo AME Church in Bowie, Maryland, moved into a new worship center financed by Industrial. Seen from left to right are Lewis Williams, commercial loan officer; Saundra Turpin, bank officer; Rev. Jonathan L. Weaver, pastor; and Ira Turpin, church treasurer. Industrial continued to finance churches when other banks would not. Pastor Weaver is also a board member of the bank. Patricia recalls that "big banks did not always want to finance churches. They were concerned that it would be bad publicity if they had to foreclose on a church. Years ago, before they realized that church financing was a lucrative business, several large banks contacted us to partner with them to finance their church loan customers."

Seven

CONTINUING THE LEGACY

Benson Doyle Mitchell Jr. was only 30 years old in March 1993 when his father died of cardiac arrest, but for the board, there was no question as to who would take control of the bank. It was time for the third generation of Mitchells to lead. The board named Doyle Jr., then vice president of commercial lending, as the new president.

The younger Mitchell knew that nothing would have made his father prouder, even though the two had never discussed it. "I knew he wanted me to follow in his footsteps," Doyle Jr. recalled. "But I can't remember him ever saying it."

Doyle Jr. came to the job with the appropriate academic heft and practical experience. He had earned a bachelor's degree in economics with a concentration in finance and accounting from Rutgers University and a diploma from the American Institute of Banking (AIB). He had been educated at private, public, and parochial schools and had spent summers in various departments of the bank since he was 16. But the larger lessons had come from watching his father—his integrity, his humility, and his compassion. "When he died, I found in his office notes from where he had lent people his personal money. Most were paid. Some weren't. Some were employees," Doyle Jr. recalled.

Patricia, the older of the siblings, had no intention of becoming a banker. Though she also worked summers at the bank and completed the AIB training, she entered a design and merchandising program at Drexel University. After several promising internships, Patricia seemed on her way. However, she went on to get a master's degree in business administration from Marymount University, worked for a short time at the bank, and then got a job at George Washington University. In the months after her father died, Patricia brought her talent and energy back to Industrial.

Doyle Jr. inherited a stable business with about $120 million in assets. Within a year, he saw an opportunity to expand when Industrial's bid to take over two John Hanson Federal Savings Bank branches succeeded. It was hailed by industry observers as a move that enabled Industrial to follow the blossoming black middle class to Prince George's County. In 1998, difficult times befell the bank when federal banking regulators pressured Industrial to improve its loan portfolio. This was not the first time banking regulators intensified its oversight on Industrial. Doyle remembers: "Regulatory pressure in banking is normal, however, sometimes it occurs with less than sufficient accuracy and understanding of the bank's market. The personal price of this level of scrutiny is very high, as my father and I have experienced." Thomas McLaurin was vice president when he found himself running the commercial loan division. "Regulators examined every area of the bank and we scrubbed it all," Doyle recalls. "The entire management team was loyal, but McLaurin and I experienced a tour of duty together." Mason Butler, Doyle's executive assistant, was also loyal during these trying times.

The executive management team includes, from left to right, Rodney Epps, Thomas Wilson, Patricia, Doyle Jr., and Thomas McLaurin.

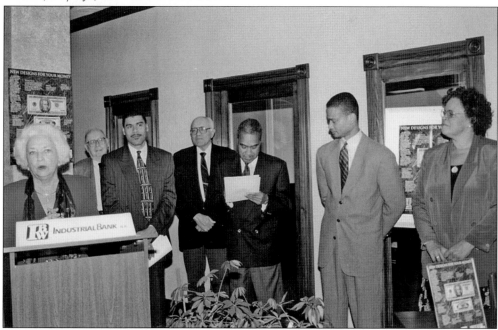

Mary Ellen Withrow, the 40th treasurer of the United States, visited Industrial on September 24, 1998, to preview the redesign of the new $20 bill, which featured enhanced security measures. Standing in the background are, from left to right, board members George Windsor, Doyle Jr., Dr. Emerson Williams, and Clinton Chapman; Ted Carter, executive director of the National Capital Revitalization Corporation; and council member Charlene Drew Jarvis.

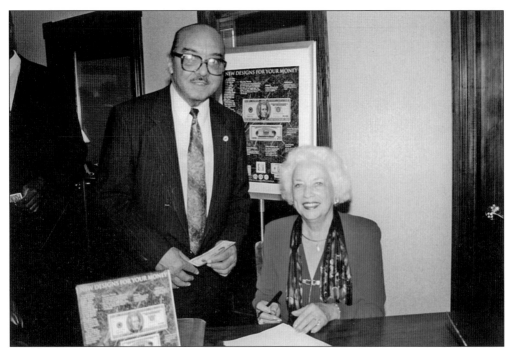

Withrow, who served as US treasurer through 2001, spoke with board member Benjamin King, the first black certified public accountant in Maryland.

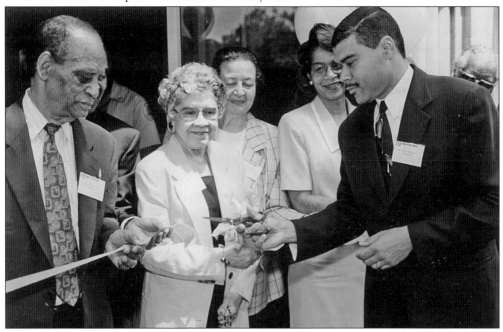

After much lobbying from the community in the mid-1990s, Industrial opened a new branch on Rhode Island Avenue in a neighborhood called Woodridge. The financial crisis of the 1990s had closed other banks in the area. From left to right are council member Harry Thomas Sr., Cynthia, and Doyle Jr. (cutting the ribbon) while Massie Fleming and Janice Booker, the owner of the branch building, look on.

The Rhode Island Avenue branch opening was a jubilant affair featuring a local choir. The branch brought convenient banking services to the community and remained a vibrant part of the neighborhood for about a decade. Another branch was opened in the early 1990s on the campus of American University after a plea from university officials concerned about the lack of banking access for students. It stayed open for about 10 years.

Officials representing Metro, the city's public transit system, presented gifts and announced that the agency named the bus stop in front of the branch in honor of the bank.

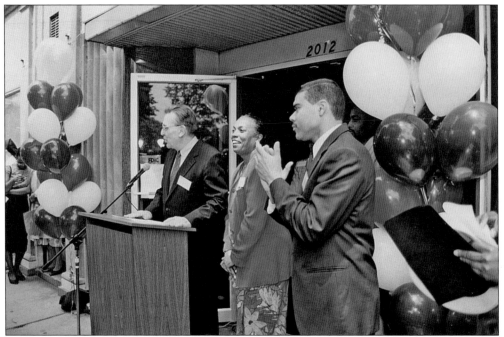

David Poole, a senior vice president at Industrial, addressed the crowd during festivities. Also shown are retail banking officer Saundra Turpin and Doyle Jr.

After the opening ceremony, Doyle Jr. was interviewed by a reporter.

Sharon Zimmerman, the assistant vice president and director of marketing, chatted with a reporter and a minister from the church across the street.

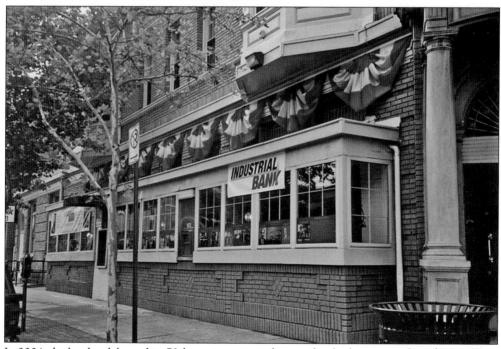

In 2004, the bank celebrated its 70th anniversary and assets that had grown to about $317 million. Bank officials also introduced several improvements to its customer service, including upgrades to its website and a partnership that gave customers no-fee access to 25,000 ATMs nationwide. Colorful draping around the U Street branch marked the anniversary.

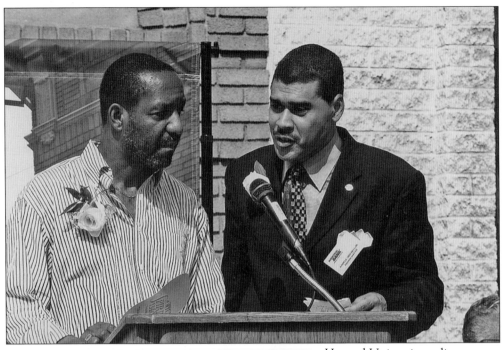

Howard University radio
and television personality
Kojo Nnamdi (left) emceed
the celebration.

Eric Price, the city's deputy
mayor for planning and
economic development,
offered congratulations to the
bank from a grateful city.

The audience enjoyed the speeches and presentations. Seated in the first row are, from left to right, Rick Lee; Thomas Wilson, a senior vice president at the bank; Wilson's wife, Diane; an unidentified man; council members Jack Evans and Vincent Orange; and an unidentified woman.

Council member David Catania, a lawyer elected as an at-large member in 1997, was among the celebrants sitting under the blazing sun.

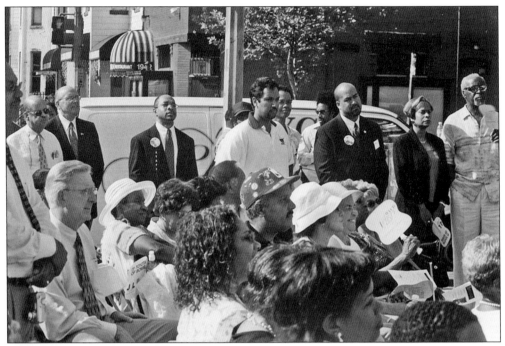

Despite the heat, officials and residents from throughout the city joined in the celebration. Audience members used old-fashioned paper fans to beat back the heat. A tent was set up for the senior board members and customers to shield them from the sun.

Former council member Charlene Drew Jarvis greeted Cynthia, the family's matriarch, during the anniversary event. Cynthia died in August 2012.

All of the Mitchell family attended the 70th anniversary celebration. Rhonda Mitchell (right), Doyle Jr.'s wife, is seen here with his aunt Annie Reid (center) and his cousin Carlene Reid (left).

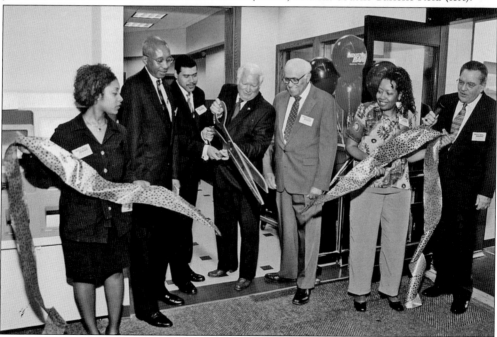

In 2001, Industrial partnered with Walmart to open a full-service bank inside the Clinton, Maryland, Walmart. Doyle Jr. and bank employees participated in a ribbon cutting inside the store. Two months later, Industrial officials opened a second branch in a Waldorf, Maryland, Walmart. A Charles County official joined Industrial and Walmart employees in celebrating the Charles County branch openings.

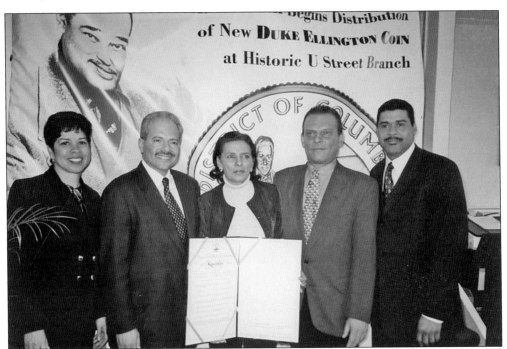

In February 2009, Industrial Bank hosted a press conference to unveil the Duke Ellington quarter, honoring the jazz legend. It was only the second US coin in circulation to feature an African American. From left to right are Patricia, Greg Hernandez of the US Mint, April Ellington, Edward Ellington Jr., and Doyle Jr. The Ellingtons are the son and daughter of Edward "Duke" Ellington.

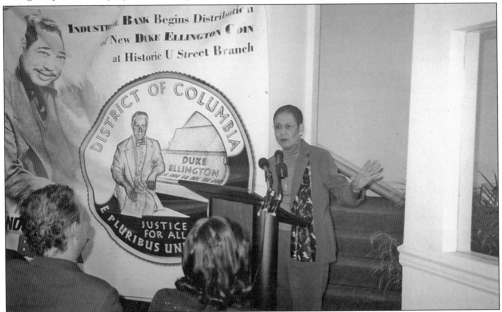

Congresswoman Eleanor Holmes Norton joined the Industrial Bank family in celebrating the distribution of the new Duke Ellington quarter. Norton was successful in passing the DC Coin Act that commissioned the coin to honor Ellington, a Washington native who helped establish U Street as an historic black entertainment corridor.

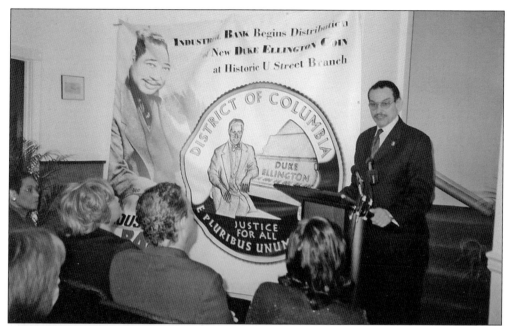

Vincent Gray, former chairman of the DC city council and Ward 7's representative, also participated in the festivities. Gray went on to become the mayor of Washington, DC.

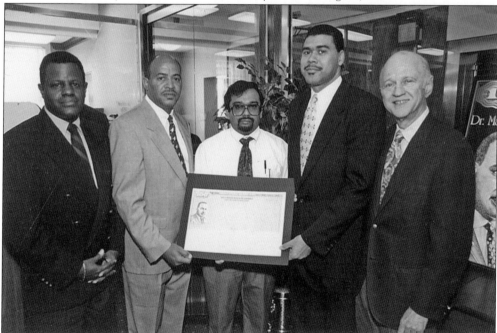

In 1998, Industrial announced a new I Savings Bond, whose $100 series honors Dr. Martin Luther King Jr. The treasury department introduced the series to encourage Americans to save for the future and protect their savings from inflation. For his leadership during the Civil Rights era, Dr. King was chosen as one of eight historical figures whose images appear on the bonds. Industrial employees Thomas Wilson (second from left), a senior vice president; Anirudh Boodram; and Doyle Jr. are flanked by treasury department officials.

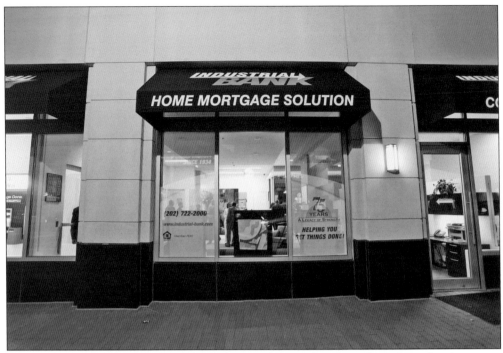

As part of its 75th anniversary, Industrial opened a new Southeast branch in the Anacostia Gateway Building at the corner of Martin Luther King Jr. Boulevard and Good Hope Road in an underserved area of the city.

Doyle Jr. welcomed guests to the opening of the branch. Among the branch's interesting features is a wall mural featuring a prominent photograph of bank founder Jesse H. Mitchell.

Speakers for the event included former mayor and city council member Marion Barry, who represents that community. Barry shared the stage with Doyle Jr. Cora Masters Barry, the president of the acclaimed Southeast Tennis and Learning Center, was another speaker.

Doyle Jr. and Patricia celebrated with their cousins, from left to right, Sharon Drew, Sherry Dailey, and Sharon's husband, Al Drew.

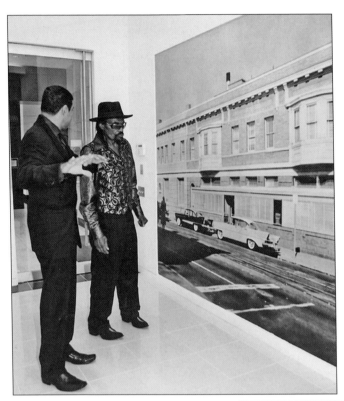

Washington legend Chuck Brown, the "Godfather of Go-Go," stopped by Industrial Bank's Southeast location in Anacostia to celebrate the release of his new CD/DVD collection on September 23, 2010. The three-disc set is entitled *We Got This!* Doyle Jr., a big go-go fan, showed the go-go icon the special mural (left) and shook hands with him (below).

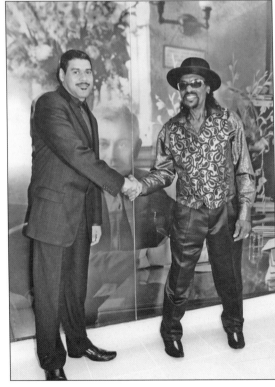

Doyle Jr. and Patricia (left) pose with recording artist Smokey Robinson, April Ellington, and Edward Ellington Jr. at the 2012 Duke Ellington School of the Arts fundraiser held at the Kennedy Center. The Ellingtons were the producers of the school's Performance Series of Legends.

Doyle Jr. married his college sweetheart, Rhonda Roberson, in 1989. They are seen here with their four children, from left to right, Benson, Emerald, Jessie, and Kendall.

Patricia worked summers at the bank, joining the business full time after college. After leaving the bank for two years in the early 1990s, she returned in 1993 as a commercial lender, responsible for making loans to small businesses. She rose to become executive vice president. "I wanted to do something independent of my family," she said. She is seen here with her son Julian.

Cordell Hayes and his sister Brenda Pace are the grandchildren of Industrial founder Jesse Mitchell. They lived with their grandparents for many years during their childhood. On his deathbed, Jesse implored Cordell to go to work for the bank. Cordell joined the family business in the early 1960s and worked there for 35 years, retiring as senior vice president.

The Mitchell family includes, from left to right, (seated) Terri Tinner holding her granddaughter; (standing) Toni, Devin, Paris, Antoine, and Danielle, all descendants of Darlene Mitchell.

Julian Mitchell's birthday party at Chucky Cheese drew almost the entire Jesse Mitchell clan, including family members from the third, fourth, and fifth generations who will find their own ways to carry on the family legacy.

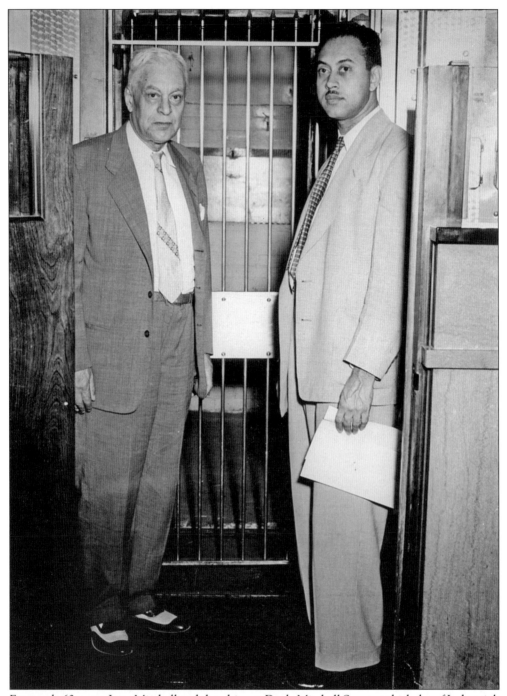

For nearly 60 years, Jesse Mitchell and then his son Doyle Mitchell Sr. sat at the helm of Industrial, steering it cautiously into the future. It survived storms that sank mightier institutions because they stayed on course and remained true to the bank's mission of serving the black community.

Doyle Mitchell Jr. learned the lessons of his father and grandfather and has built on their success with slow but steady growth, cautious yet innovative leadership, and a core purpose that remains as important today as it was in 1934.

DISCOVER THOUSANDS OF LOCAL HISTORY BOOKS FEATURING MILLIONS OF VINTAGE IMAGES

Arcadia Publishing, the leading local history publisher in the United States, is committed to making history accessible and meaningful through publishing books that celebrate and preserve the heritage of America's people and places.

Find more books like this at
www.arcadiapublishing.com

Search for your hometown history, your old stomping grounds, and even your favorite sports team.